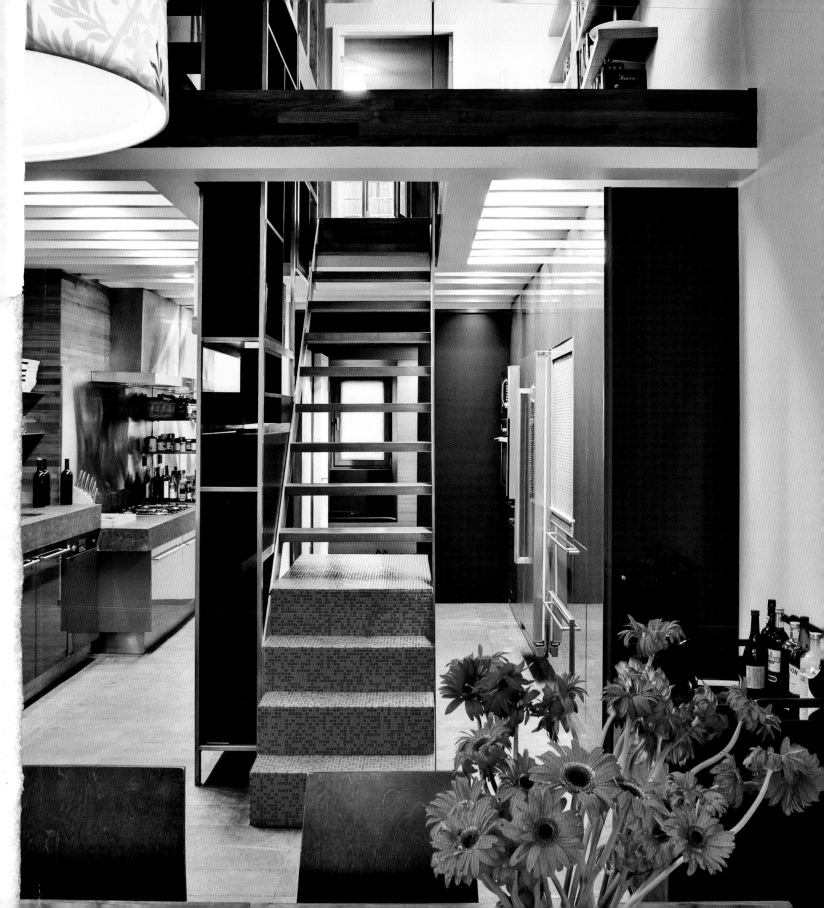

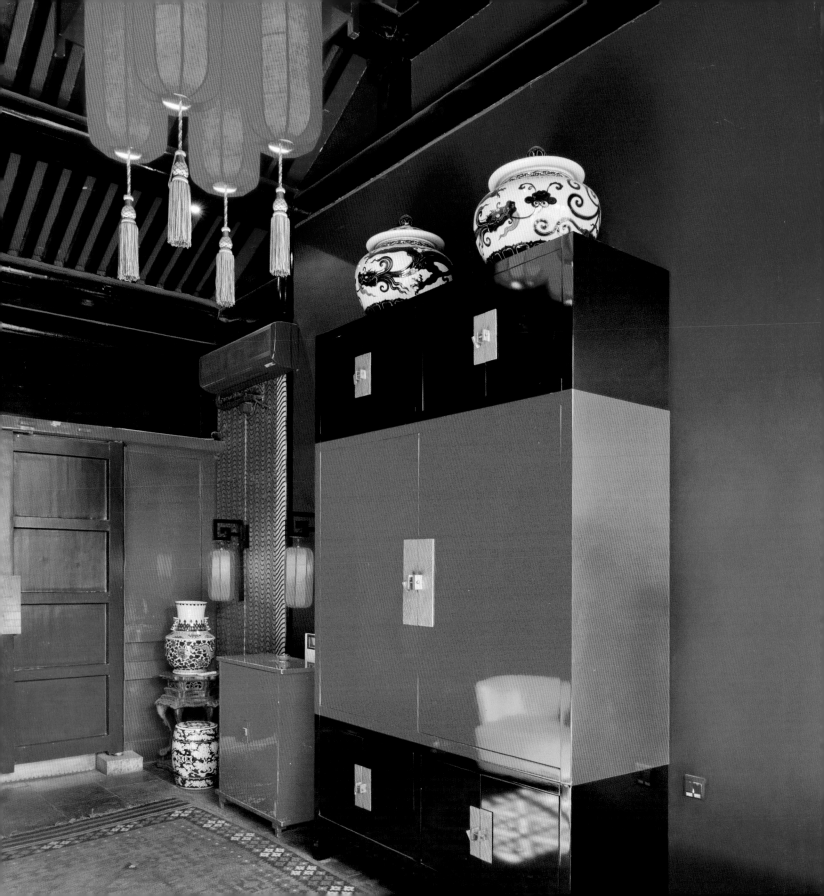

CHINA HOME

Inspirational Design Ideas

MICHAEL FREEMAN
with YAO JING

TUTTLE Publishing

Tokyo | Rutland, Vermont | Singapore

Published by Tuttle Publishing, an imprint of
Periplus Editions (HK) Ltd

www.tuttlepublishing.com

Text and photographs copyright © 2012
Michael Freeman

ISBN 978-0-8048-3981-5

Distributed by:

North America, Latin America & Europe
Tuttle Publishing
364 Innovation Drive
North Clarendon, VT 05759-9436, USA
Tel: 1 (802) 773-8930; Fax: 1 (802) 773-6993
info@tuttlepublishing.com
www.tuttlepublishing.com

Japan
Tuttle Publishing
Yaekari Building, 3rd Floor,
5-4-12 Osaki, Shinagawa-ku
Tokyo 141-0032
Tel: (81) 3 5437-0171; Fax: (81) 3 5437-0755
sales@tuttle.co.jp
www.tuttle.co.jp

Asia Pacific
Berkeley Books Pte Ltd
61 Tai Seng Avenue, #02-12, Singapore 534167
Tel: (65) 6280-1330; Fax: (65) 6280-6290
inquiries@periplus.com.sg
www.periplus.com

15 14 13 12 10 9 8 7 6 5 4 3 2 1

Printed in Hong Kong 1111EP

A detached house in Shanghai furnished by owner
and gallerist Elisabeth de Brabant, contains folding
Ming horseshoe chairs, Tang dynasty horse sculp-
tures and photographs by artist Wang Xiao Hui.

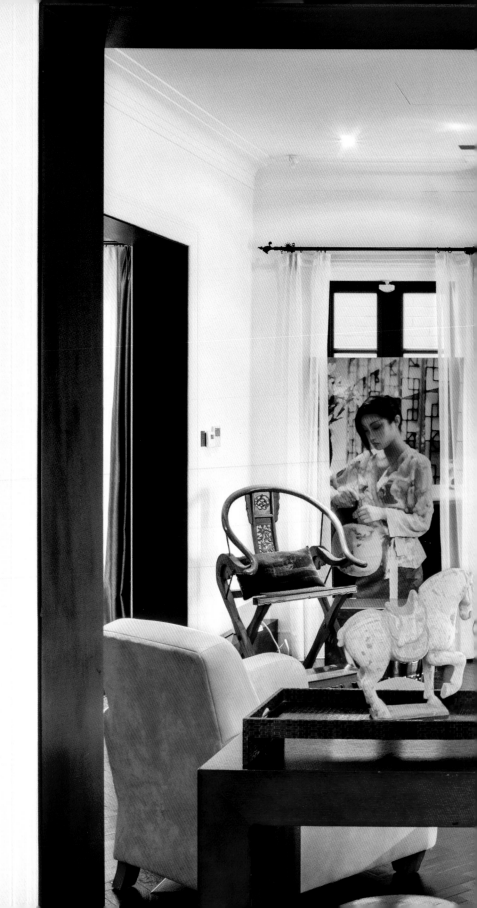

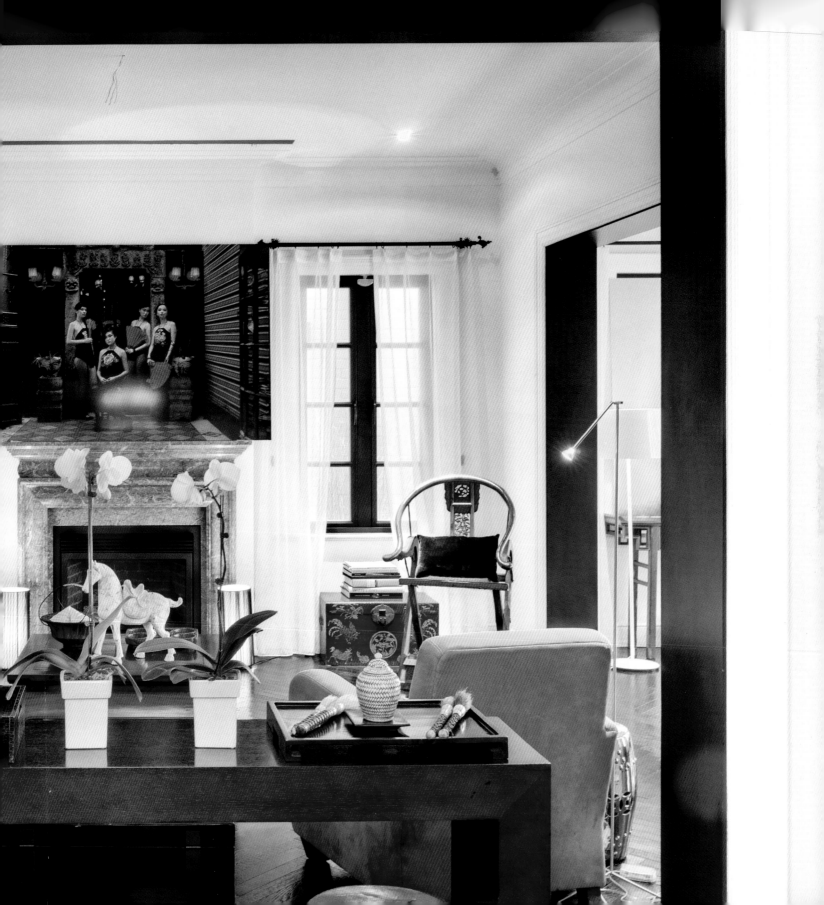

CONTENTS

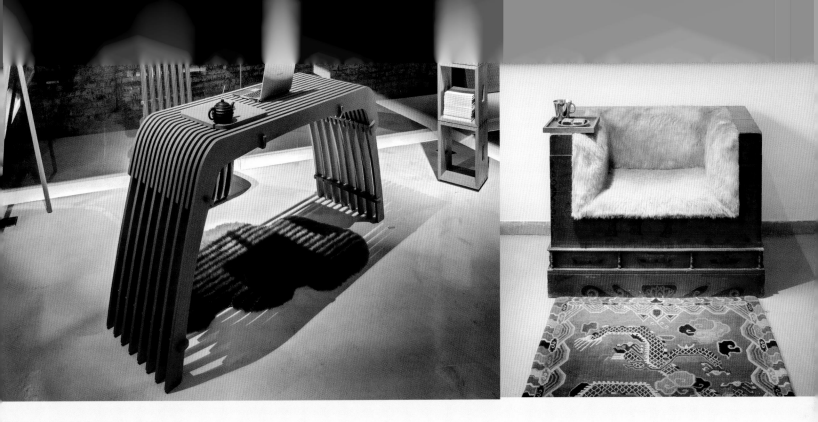

DESIGNING THE CONTEMPORARY CHINESE HOME

Homes are fundamentally spaces, and the traditional Chinese conception of space demands an appreciation of unity, wholeness, balance and symmetry. In the Chinese world-view, there is inter-connectedness, and the home—how it is arranged and what it contains—cannot exist independently. We can see a recurring and well-defined spatial theme in Chinese history that covers philoso-phy, religious thought, art and design. Spatial qualities are rhythmic, and crisscrossed and interwoven into a fine texture that mirrors nature, a tapestry comprising *yin* and *yang*, *wuxing* (the Five Elements) or the phases of the dynamic sixty-four trigrams. In this sense, the traditional Chinese house is predominantly based upon a planar spatial schema, with orientation a key element. The axis was the primary orientational reference. From the records, east–west orientation once occupied the principal place in Chinese culture instead of north–south orientation. Such traditions, over time, became the ordering structure in interior layouts; for example, in the inner halls of Chinese houses, the west was usually reserved for sleeping and the east for daily activities.

Equally important is an understanding of the Chinese physical envi-ronment as a result of a syncretic relationship between Confucian-ism, Taoism and Buddhism. One of the effects of this was the way in which the home space was related to the surroundings, which affects not just the architecture of the buildings but also the view from within and how that connects interior with exterior. The influ-ence of the concept of the courtyard house is hard to overestimate,

The entrance hall to the Beijing house of artist Shao Fan, which he designed himself. A freestanding wall clad in dark gray wood follows traditional principles of breaking a straight-line view from the door, behind and into the house and courtyard.

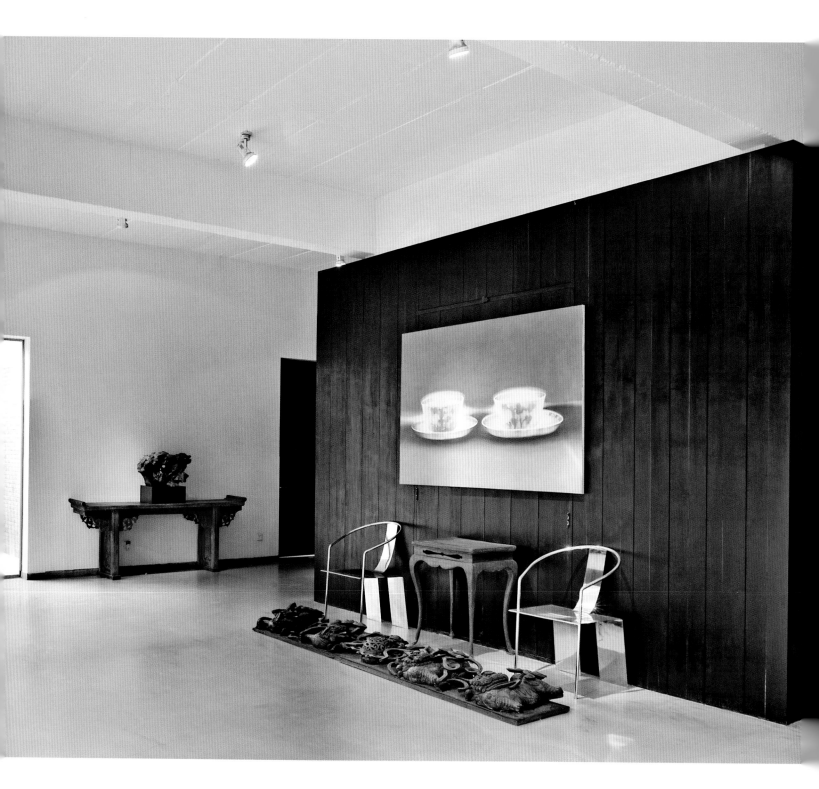

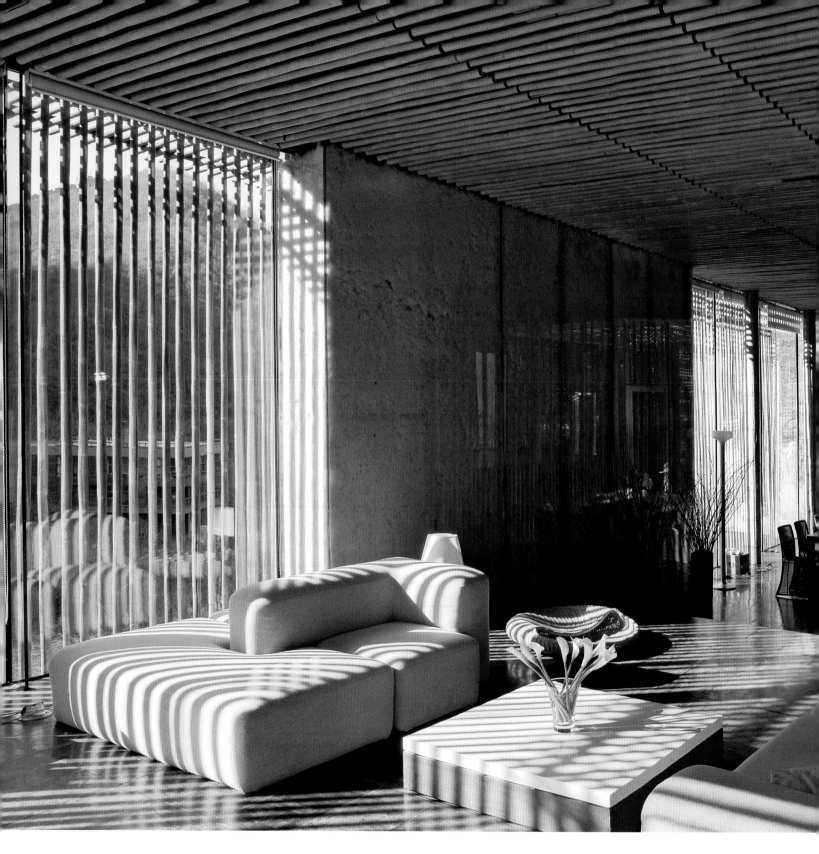

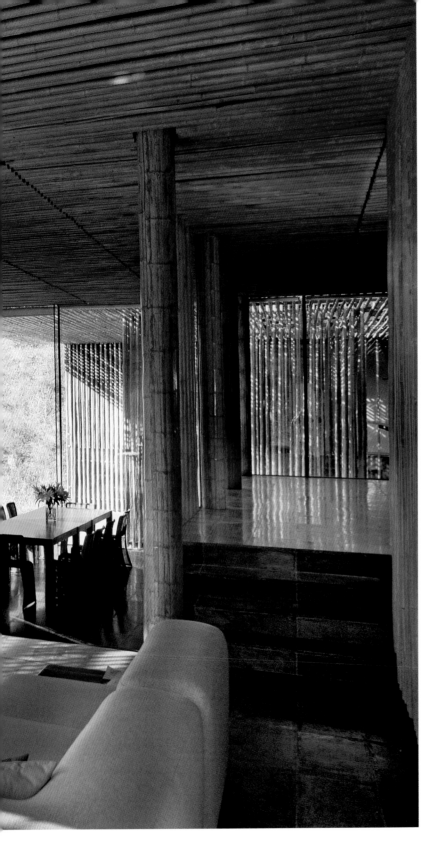

The Bamboo Wall House, designed by architect Kengo Kuma, makes deliberate use of cheap construction materials—the poles used in scaffolding—but integrated with smoother and softer materials, such as the plastic box wall encasing feathers and the cloth-upholstered sofas.

even though such courtyards themselves are absent from the majority of contemporary homes. One of the functions of the courtyard was to ensure privacy for the family, of course, while creating a common area onto which individual interior spaces opened. But it also fulfilled the important function of reminding and emphasizing the oneness of man and nature. The enclosed open space within a home is a microcosm of the natural world, bringing the symbols and details of nature into a shared space. Courtyard in this sense also stands for gardens, terraces and even balconies, and in the details of structure we can see how architects and designers work to make sure that the interior and exterior interpenetrate each other. Bringing the natural world into the home, even if in symbolic form, such as carefully chosen rocks, is the legacy of this original Chinese idea.

These values of space inherited from tradition are now being reinterpreted. The scale of this was heavily influenced by the first round of real estate development in China, which since 1997 awoke a certain awareness of design and architecture, with the launching of magazines in this domain that began to explore what should be China's own way of contemporary living. This was accompanied by the end of the traditional welfare housing allocation system in Chinese cities and the large-scale residential development of Bi Guiyuan in Panyu in Guangzhou. Two particular events reflected this change. One was when the now hugely successful Soho developers Pan Shiyi and Zhang Xin commissioned architect Yung Ho Chang to design and construct a country villa for them, creating a vogue of modern architectural design which broke the popularity of the European

The Zhong Ya Ling apartment in Pudong uses white as a foundation for a geometrical arrangement of elements. At the entrance is a display area, a full-height mirror and an antique jacket in the stairwell.

classical style. A second was the reconstruction of abandoned warehouse space along Shanghai's Suzhou Creek by Taiwanese architect Deng Kun Yen. Despite initial resistance, this sparked a re-examination of abandoned aesthetics that showed the possibility of integrating old and new, and made a positive impact on later interior design. At that time, Wang Mingxian wrote in his *Fragments of Space History*, "It expressed the participation in current culture with avant-garde colors which embody a brand-new space concept."

We say 'traditional' but this does not mean past and gone. Despite the huge, century-long disruption of Chinese society and culture, there is now a revival of interest in the rich history of Chinese belief, thought and artistic sensibility that are ultimately expressed in a way of life. That way of life is naturally reflected in the home space. With the current rapid social development and changes, many Chinese are eager to trace and recover lost cultural traditions and to redefine a Chinese sense in their homes, as a kind of 'oasis' in the strange and fragmented outer world. Chinese architects and designers operate in this context, and the best of them are working in ways that attempt to integrate international design vision and professional experience into China's reality for Chinese living. Naturally, their views vary in how to balance international concepts—for which read Western, essentially—and Chinese sensibility. At one end of the spectrum, Shao Fan, whose house appears here, believes that a true fusion of Western and Chinese art and design is not possible, and that the Chinese should concentrate on articulating their own cultural legacy. This means understanding not just the history of artistic and design development over the

dynasties but also the world-view that these express. As an internationally recognized artist, designer, architect and garden designer, in the tradition of the literati (*wen ren*), Shao is particularly well-placed to comment on the contemporary development of Chinese ways of living. He claims to be an unrepentant classicist, and draws strength and ideas from as far back as the Song dynasty, as evidenced in the houses he has built for himself and his friends. Like fellow artist Ai Weiwei, his self-designed house is a contemporary evolution of the traditional courtyard house, in gray brick and using modern materials as appropriate to create a series of interlocking spaces that turn the dwelling into a varied, comfortable and even philosophical experience. In both Shao and Ai's concept of this form, interior volumes have been enlarged and simplified in terms of actual space and height, and in the way they draw in more light than was traditional.

Others see the ideal as a response to a new interpretation of Chinese lifestyle, one that fully embraces certain international modern aspects. How to bring about the integration of modern needs with traditional values is problematic, and the relative proportions accorded to modernity and tradition vary widely throughout this book. Both Zhong Song and Anderson Lee, for example, work conceptually with traditional Chinese techniques of space management, and bring this design economy to bear on modern apartment dwellings. The result according to casual observation shows more modernist sense than Chinese, with a marked absence of well-known Chinese traditional design motifs, yet this is the result of integrating modern and traditional at a deeper, conceptual level.

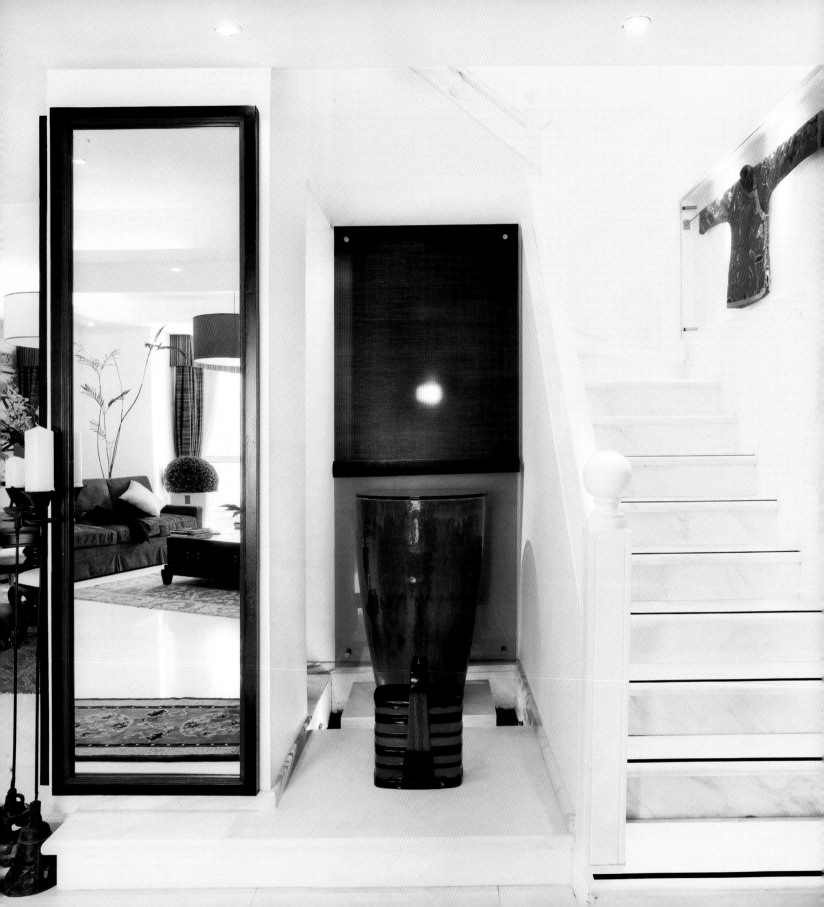

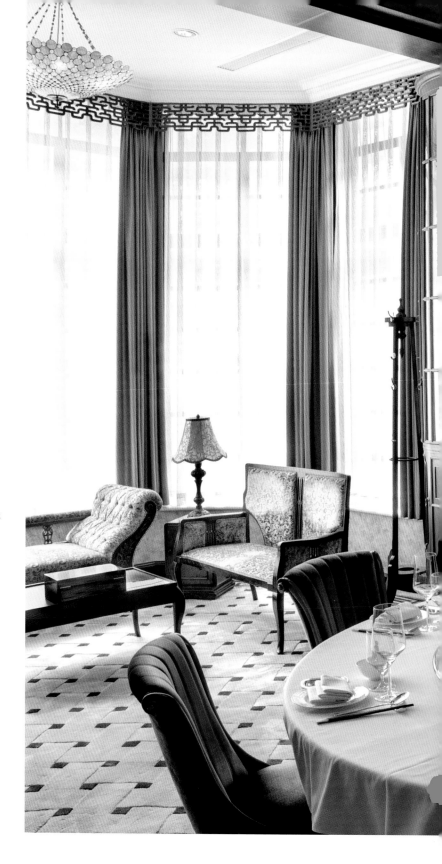

The family dining room of the Pei family mansion, built in 1934 in Shanghai, with a hand-painted screen covering one wall. This blend of Chinese and Western was an identifiable feature of the lifestyle of the city's wealthy in the early twentieth century. The renowned architect I. M. Pei was born into this family of merchants and bankers.

Renovation of existing architecture and style has been another significant strand, but one that came relatively late. Deng Kun Yen, mentioned above, who moved from Taiwan to Shanghai, played a key role with his conversions of warehouses along the Suzhou Creek, something that the city authorities at the time found perplexing. Sweeping away the past and rebuilding from scratch had become an unquestioned ideal until then. Subsequently, the value of China's heritage has become widely recognized, though not before some beautiful homes had been bulldozed. The various skills and techniques needed in a thorough restoration, from structural to decorative, have been developed, and through this development has come an even greater appreciation of the different stylistic periods of design, including Ming, Qing, Republican, Shanghainese Art Deco, and even the utilitarian 1950s. And, in case this revival of past styles seems too deadly serious, there are many instances of playfulness and irony in the use of motifs, particularly from the Mao period, as we see dotted throughout this book.

Ultimately, designing for the way we live is a matter of understanding space. How that space is colored, lit, furnished and connected to its neighboring spaces is the result, and it can deeply affect the well-being of the people who live there. Meaningless decoration, all too easily applied by developers, simply fails to fulfill the potential. Here we have a unique possibility of China's contemporary design practice being responsible for its own future, projecting the Chinese dream onto a way of living.

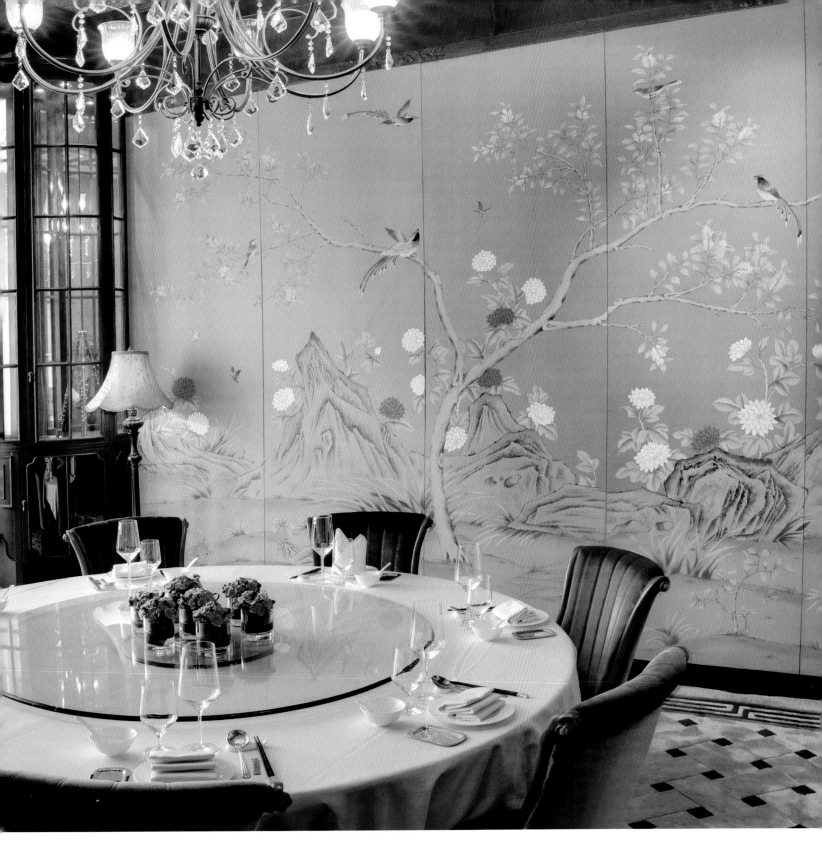

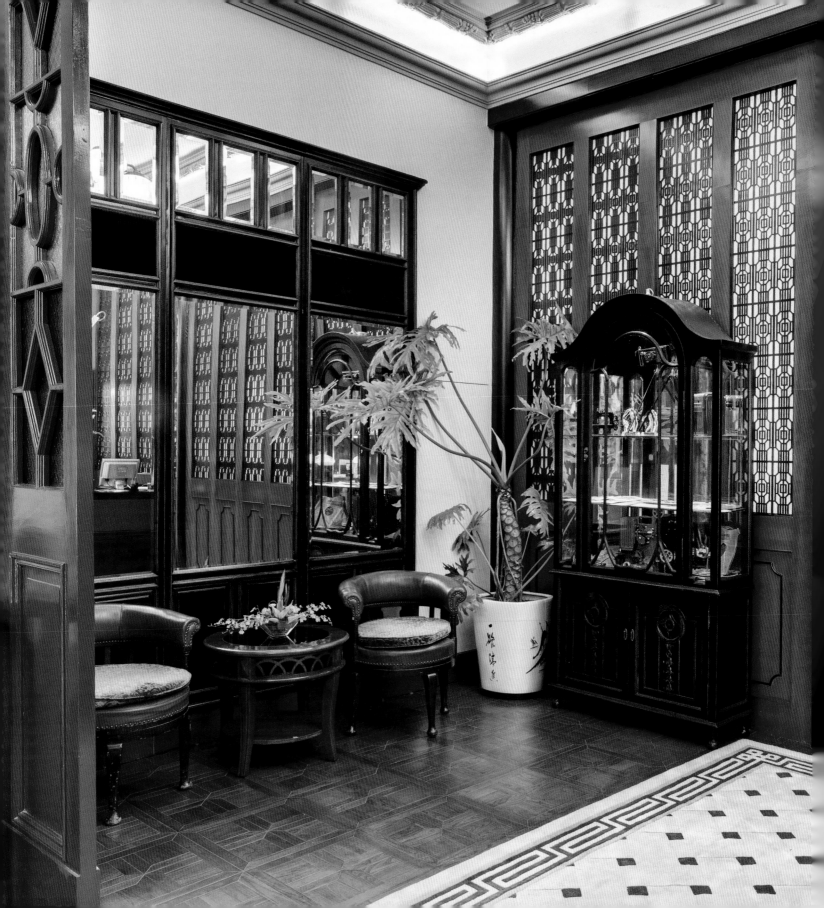

ENTRANCES AND LIVING SPACES

In the Chinese view of a house, entrance and living space are inseparable, and the linking derives from the central concept of courtyard, which is the subject of Chapter 5 (page 130). With individual dwelling units surrounding this inner area, the significance of interior entrances developed, while the centralized organization reflected the importance and privacy of the family. This tradition is naturally challenged by the rapid move to apartment dwelling in the cities, but some of the sense and symbolism remain, beginning with the entrance itself.

Doors have always been a keynote feature of a Chinese house; they are visually eye-catching but also arouse a certain sense of mystery—open they welcome the visitor into the hub of the home, closed they maintain suspense. On the one hand they protect—extremely important both notionally as well as practically to the role of the family in Chinese life—and on the other they invite the visitor, for hospitality has long been an essential feature of Chinese society and is integral to the strength of any individual family's life.

The sequence of entering moves from door to vestibule to principal living space, which is how this chapter is organized. Traditionally, space in a Chinese home, except for the very wealthy, has been minimal at best, but with China's economic boom, massive program of home building and the inevitable changes in society, room space in dwellings is expanding. For more and more Chinese, the living space is becoming a focus of two thing: personal comfort and personal expression.

Art Deco screen doors at the end of the large vestibule of the Pei family mansion in Shanghai.

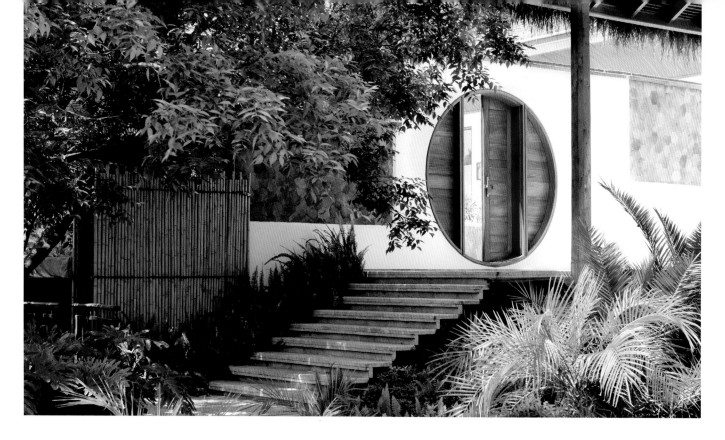

THE IMPORTANCE
OF ENTRANCE

Entrances and the doors that fit them have a particular significance in the Chinese history of dwellings because of the special notions of privacy. A traditional Chinese house is, in fact, a compound with walls and habitations organized around a courtyard, and the entrance transcends the usual function to enter a private world, traditionally into a garden area where one can experience the pleasure of outdoor leisure, encircled by natural environment. We explore this theme later in the book. The direction of the front door matters more than most other Feng Shui considerations, and is considered to be the 'mouth' as the most all-important *qi* enters the building through this direction. Moongates, four of which are featured here, have been used for many centuries. Their circular form symbolizes perfection and also acts to focus, intensify and frame what lies beyond.

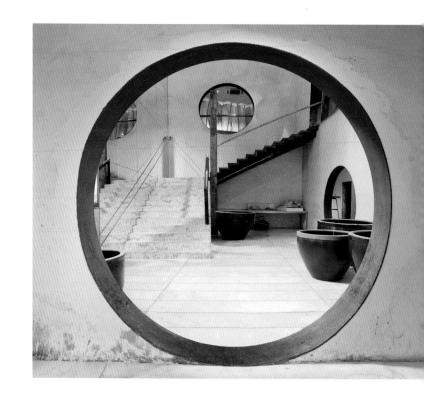

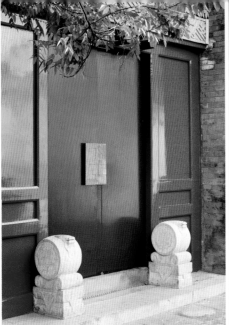
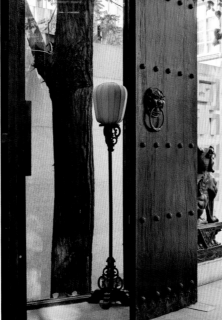

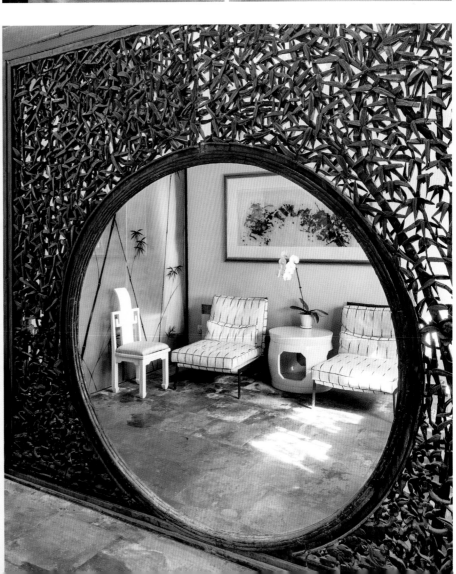

Above A typical courtyard house in a *hutong* in Beijing has its entrance on the south wall. The two flanking stones are traditional, used originally for mounting horses and showing off a family's wealth and status.

Above center A heavy antique wooden door is given apparent lightness by being set into a glass wall in this Beijing entrance.

Above right A sliding steel door opening onto a simple garden courtyard in Shanghai's Xuhui district is a contemporary take on the protective/revealing role of the Chinese entrance.

Opposite above An adaptation of a moongate with a sliding wooden door enters a villa on the outskirts of Kunming. The staircase ascending to the main gate has symbolic significance, indicating the beginning of a journey.

Left Taiwanese architect Deng Kun Yen makes extensive use of interior moon doorways and windows in his Shanghai complex. The main entrance is mirrored in a second doorway and an upper floor window beyond.

Right In a restored Beijing *hutong*, a carved wooden moongate connects study and bedroom. The elegant openwork also conflates doorway with screen, an equally important Chinese element.

Below Flanked by water, the approach to a villa in Fuchun, near Hangzhou, passes through an outer court to an inner, combining modern simplicity and lighting with a traditional format.

Right A stone lion stands guard at the entrance to the largest single apartment on New York's Fifth Avenue, paneled in Georgia pine, and owned by Robert Ellsworth, one of the greatest collectors of Chinese artifacts.

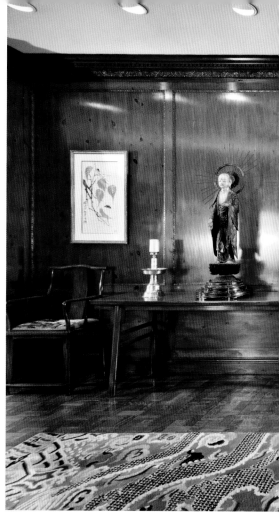

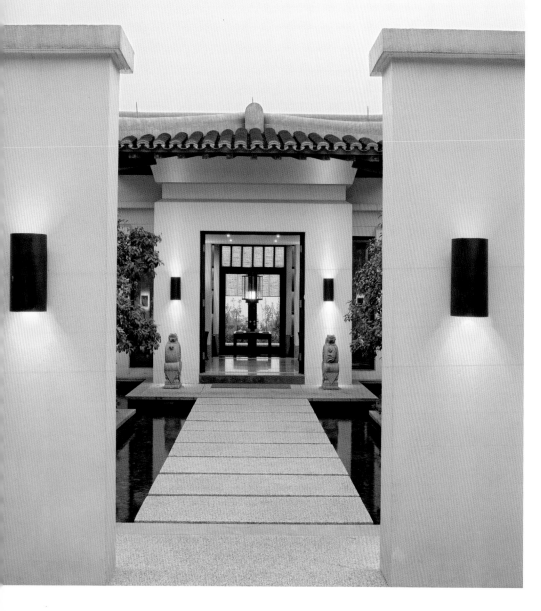

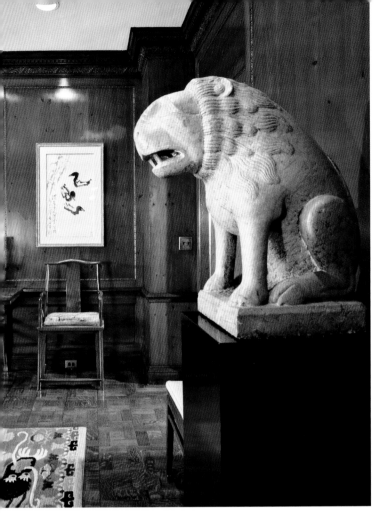

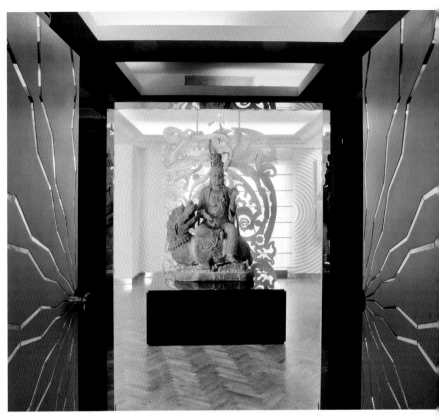

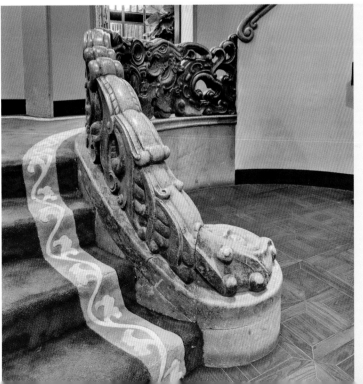

Above From a lobby paneled with etched-glass walls, the focus of the entrance to Pearl Lam's penthouse apartment in Shanghai is a stone Buddhist statue of Guan-Yin.

Left An elaborate carved stone dragon forms the impressive balustrade to the curved staircase in the 1930s Pei mansion, Shanghai.

Center left A succession of moongates in unpainted brick is a distinctive feature in architect Deng Kun Yen's complex in Yangpu district, Shanghai.

ENTRANCES AND LIVING SPACES

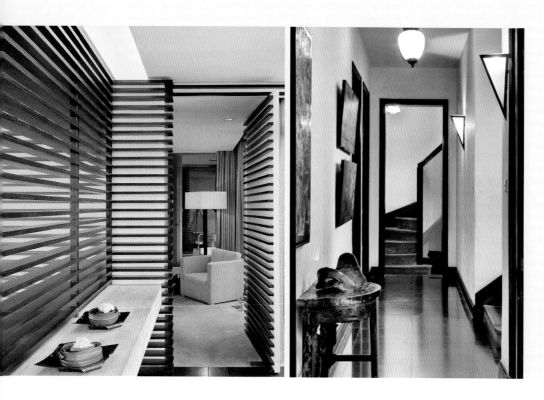

Far left Parallel dark wooden slats line the wall and door of this entrance hallway to give a strong sense of forward trajectory.
Left The entrance to the Hong Merchant House in Shanghai's French Concession is a corridor perpendicular to the main door. Dark brown edging against white is typically Art Deco of the period.
Below White (including the reproduction Ming chairs) and natural wood dominate this vestibule. Laminated wood carved into a free-flowing shape provides seating for guests in a form that seems to blend with the structure of the room.

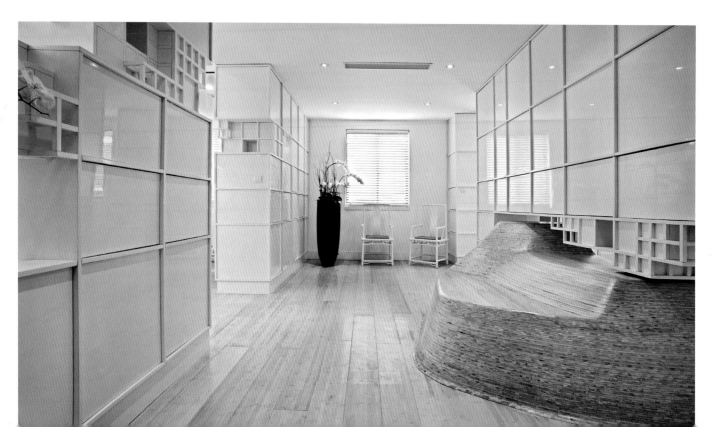

LOBBY AND
VESTIBULE

The importance of entrance and the symbolism of the door
that we just saw confers a different role on the vestibule of a Chinese house. This is a quiet yet important space and the walkway
between main door and living room. In contemporary usage, a
vestibule occupies the area surrounding the exterior door and is
linked to it more than to the main living area. It is the immediate
space once the visitor is inside, though not yet as far as the main
interior of the building—a kind of 'air lock' in a utilitarian sense.
More than this, however, vestibules are responsible for creating
an atmosphere of invitation and welcome, and so are very much
spaces 'belonging' to guests. Elements such as warm lights, even
a mirror to expand the apparent size and make it look more open,
play a role, while natural elements such as plants and stones help
declare the house's environmental soundness.

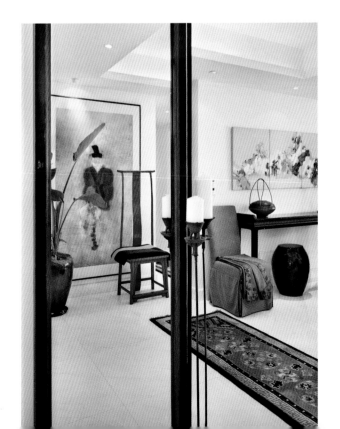

Above The entrance to a bourgeois 1920s house in Shanghai, Ke Tang Jian,
is enlivened with benches and throw cushions in strong, contrasting colors.
Left In a new Pudong apartment, across the Huangpu River from Shanghai,
a long Tibetan carpet reinforces the sense of entry. The arrangement of furniture
is for formal display rather than everyday use.

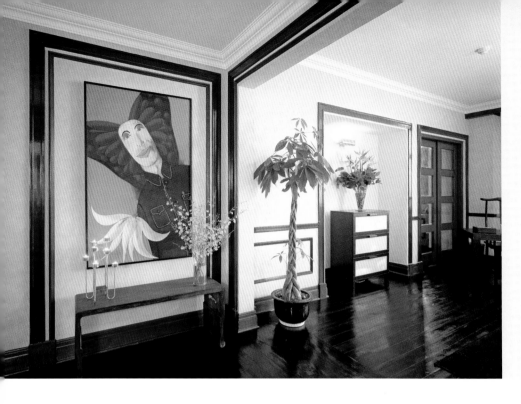

Left The entrance hall of an Art Deco apartment in the 1930s Grosvenor House, Shanghai, with contemporary art added—a 1995 painting by Shen Fan.

Below Pillar rugs and Ming horseshoe chairs in Robert Ellsworth's large paneled apartment. The dragon rug was intended originally to wrap around a pillar in an Imperial palace.

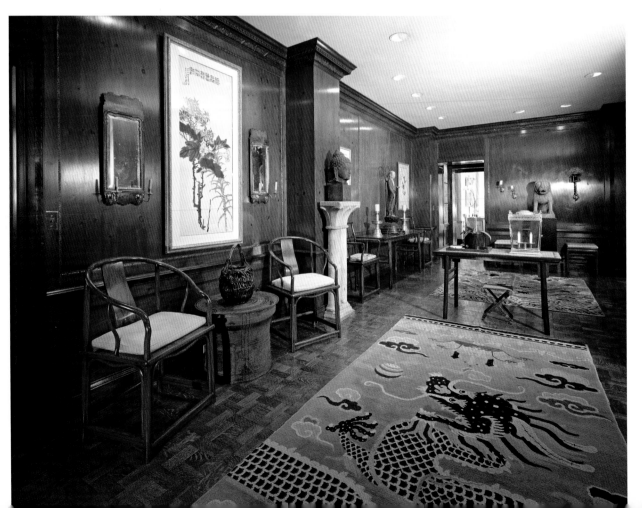

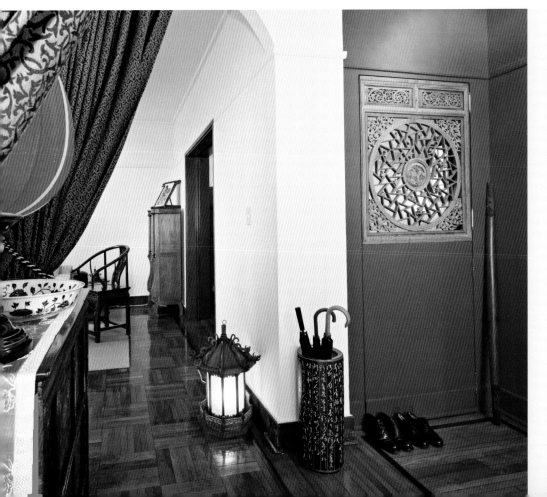

Above left Aluminium cladding covers an idiosyncratic entrance of counter-curved strips in a Beijing apartment.

Above A loft space converted from an old printing factory in Beijing makes use of the contrast between the all-white conversion and the exposed brickwork and timbers above head height.

Left The entrance to an Art Deco apartment on Shanghai's central Huaihai Road. The display at left facing the door (out of frame at right) features a Tibetan painted chest with silk embroidered table runner and red lamp, flanked by patterned curtains.

ENTRANCES AND LIVING SPACES

THE SIMPLICITY OF **WHITE AND GRAY**

At the core of Chinese interior design is the art of bringing together simplicity, modernity, the contemporary and nature to make an environment of harmony and serenity, with quality and craftsmanship the focal point of everything within its uncluttered lines. In this traditional view, there is a rich confluence of Confucian, Taoist and Zen Buddhist traditions, and in the approach to color it tends to lead towards the cleanness of white and neutral tones. Differentiating itself from the traditional largely expected red color, the inspired decor in an increasing number of modern Chinese houses is a kind of bright restraint, whiteness leading a range of colors that reflect more of nature, such as brown, gray and tan. Other colors are brought to the forefront in this style, added as accents upon the room's canvas of neutral tones.

Left White and beige provide the linking theme for this penthouse apartment in the converted former 1930s Union Brewery overlooking Shanghai's Suzhou River. Chain curtains, also in white, screen off the sleeping area.
Right Architect and designer Jiang Tao chose shades of gray as the theme for this minimalist Beijing apartment, with an unadorned polished stone flagged floor.
Below The living room of one of China's best-known artists, Yue Min Jun, with a sculpture by the artist overlooking the living area from the upper floor walkway. Designed by Chen Jia Gang, the space is conceived as functional, spacious and white, in deliberate contrast to the artist's graphically powerful work.

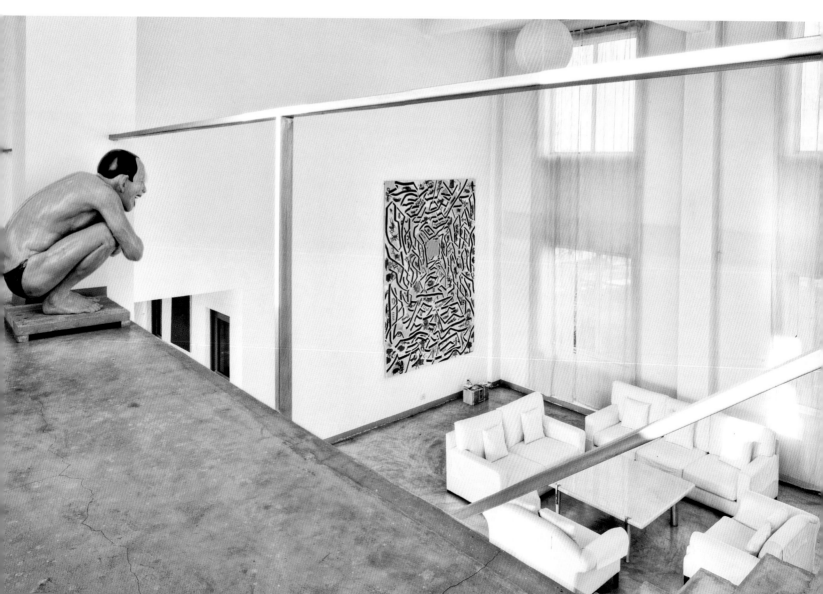

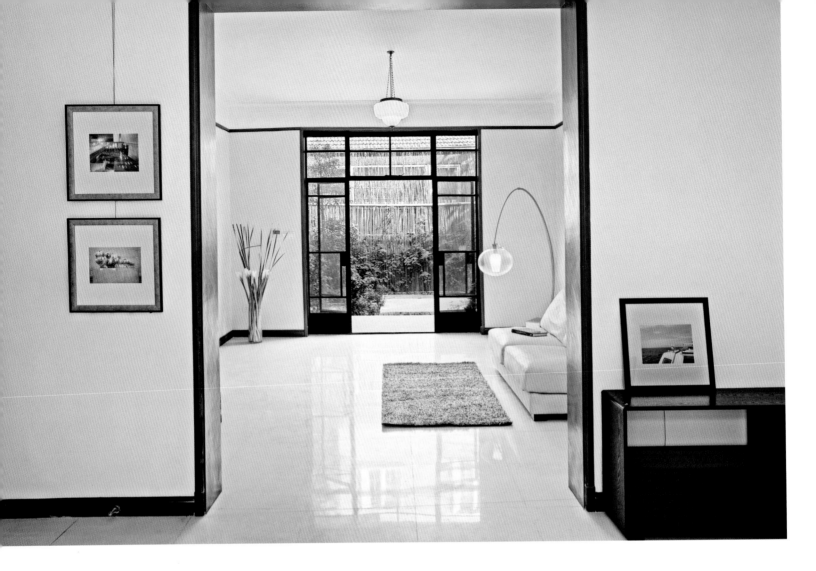

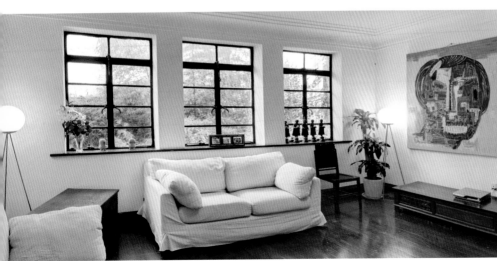

Above In a minimalist conversion of a double-bayed 1930s lane house in Shanghai by the architectural cooperative sciskewcollaborative, the original Art Deco rectangular geometry is emphasized with an all-white finish to walls, floor and ceiling.
Left The first floor sitting room of a French Concession house in Shanghai, in white, with a 2006 painting, 'Chinese Woman' by artist Shan Gang, providing the color focus.

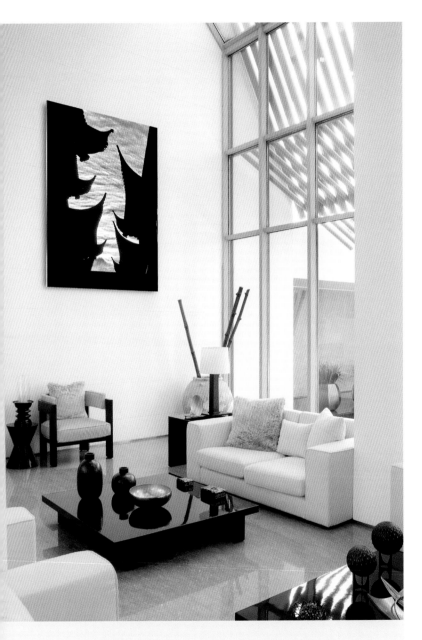

Above White walls, ceiling and sofa over a natural wood floor alleviate the cramped potential of this room under a mansard roof.
Below Extensive use of white brings an apparent expansion of space in the small Beijing apartment of architect and designer Zhong Song.

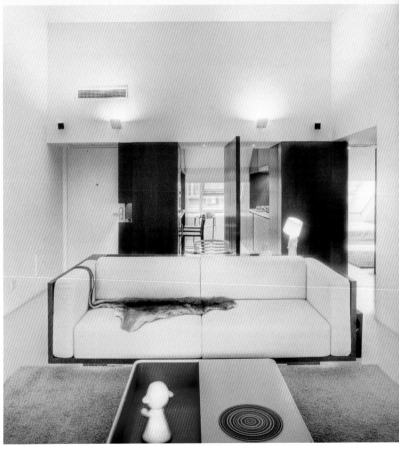

Above The gilded interior of a bowl provides the single color accent in this Pudong villa. Floor-to-ceiling double-height glass floods the large space with light.

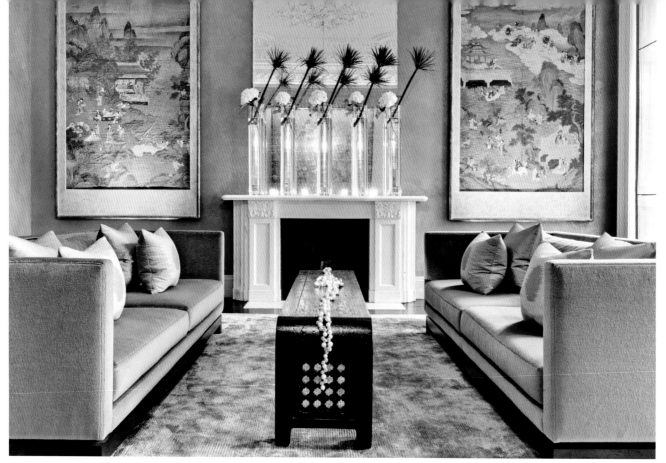

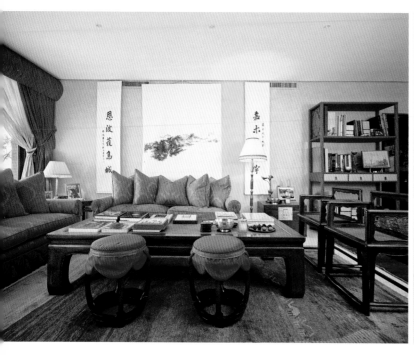

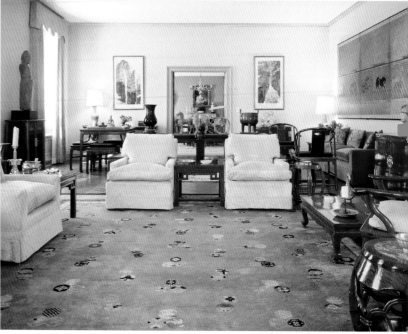

FORMAL **LIVING ROOMS**

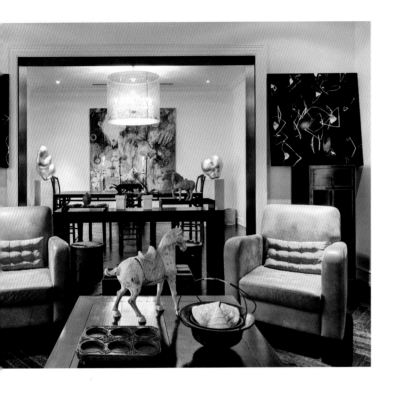

The formal style retains a strong hold in Chinese interiors, in particular for the main living space. This is a place to entertain guests, converse with acquaintances and host formal affairs inside the home. Design involves a wide assortment of seating and display areas, together with decoration that reflects the owner's personal style. In the contemporary Chinese house, luxury living space is being redefined, with elegance becoming increasingly sought. Meanwhile, apportioning traditional design values to this entertaining space while saving the informalities for the family room is always a key issue. A formal living room is, furthermore, designated in the philosophy of Feng Shui as a room of opportunity. When an old friend or neighbor arrives unexpectedly, the living room will be one of the first rooms they are able to enjoy. This is a place of potential, the room linked to several aspects of life, including career and relationships. From a more practical standpoint, a well-designed living room will provide your guests with distinct feelings of security about you and about the time they spend inside your house.

Above left Strict symmetry focused on the fireplace confers formality on this spacious first floor living room. The pearl and gilt strand table decoration on the low Chinese lute table is by designer Cyril Gonzalez.
Above The living room, looking through to the dining room, of gallery owner Elisabeth de Brabant's 1930s Xuhui house. Symmetry of armchairs, cabinets and paintings work a similar formal effect as in the room at top left.

Far left The living room of Grace Wu Bruce's Hong Kong home, featuring an important collection of Ming furniture. A pair of calligraphy scrolls by Wang Shixiang flank a landscape scroll painting by Hong Kong artist Harold Wong. The table is a late Ming daybed. In the foreground is a pair of barrel stools in *huanghuali* with upholstered seats.
Left A large late seventeenth-century Chinese carpet dominates this living room, which looks through to a dining room, flanked by two modern mountain/water landscapes by Fu Bao Shih, 1940.
Right A Hong Kong Mid-Levels apartment in the grand style, home of renowned collector and jewelry designer Kai Yin Lo. An eighteenth-century *nan mu* seating platform in three sections functions as a coffee table.

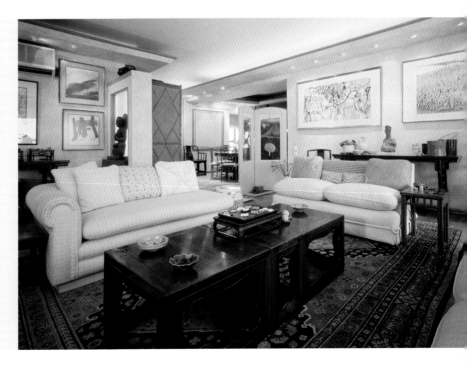

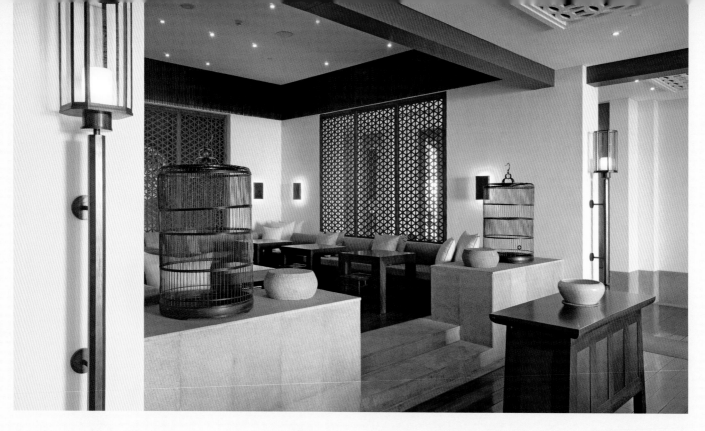

Below The living room of a Hong Kong apartment owned by a collector and designer with a passion for fine Ming furniture and stones. In the foreground, a yellow Lashi river stone with a typically waxy polish symbolizes nature. Behind is a classic Ming lute table and cabinet, with scroll paintings and calligraphy.

Below Another Hong Kong Mid-Levels apartment living room, combining a contemporary cream sofa with a Ming daybed, and collections of jade, Tibetan silver, ironwood figures and antique beads.

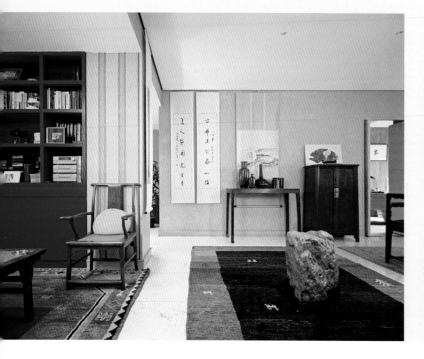

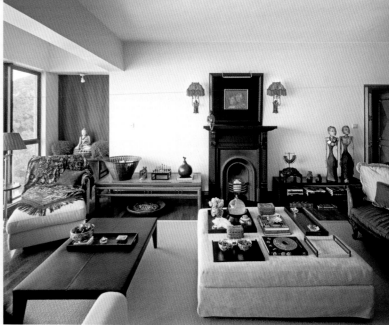

Left The living room of a contemporary Hangzhou villa that incorporates traditional elements is raised above the entry level. Antique birdcages flank the entrance, and three walls are screened with wood latticework.

Right Restrained tones and natural colors are the hallmark of this small but elegant living room. A dark camphor wood trunk from Macau with table runner abuts a contemporary white-upholstered sofa.

Below A combination of Ming and Art Deco furniture on a contemporary carpet inspired by traditional Chinese motifs. In the foreground is a circular 1930s Shanghai maple wood table with stools. Behind is a Ming *huanghuali* table and two chairs with 'cracked-ice' backs.

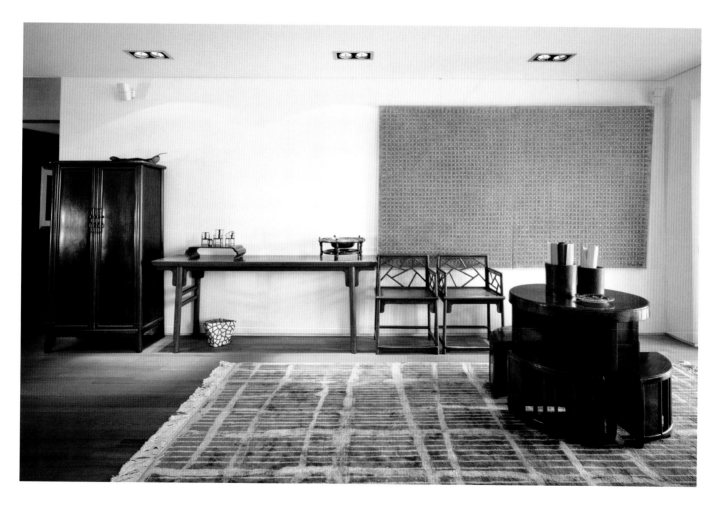

LIVING WITH **ART**

Thanks to the booming contemporary art market in China, as well as the deft eye of a new wave of audacious modern designers, there is a new class of patron of contemporary art and design who are incorporating it into their home decoration. New art spaces penetrating the home serve as incubators for a rapidly expanding network of art galleries. From the moment you step into one of these art spaces in a Chinese house you are a supporting actor in a theater of the owner's creation. Probably the exemplar is Pearl Lam's Shanghai apartment, which has inspired many others. There is a main stage of glittering, mirrored glass, rich silks and glamorous daybeds, displaying some of the most exciting contemporary Chinese art. The double-length apartment (indeed, two apartments with the dividing walls removed) is long enough to give the feeling of a gallery; the walls undulate with massive bas-relief swirls concealing built-in doors. A computer-operated lighting system projects saturated color onto the walls, creating theatrical shadows. An increasing number of wealthy Chinese are seeking their own distinctive way of living in relation to art, incorporating it into their home lives.

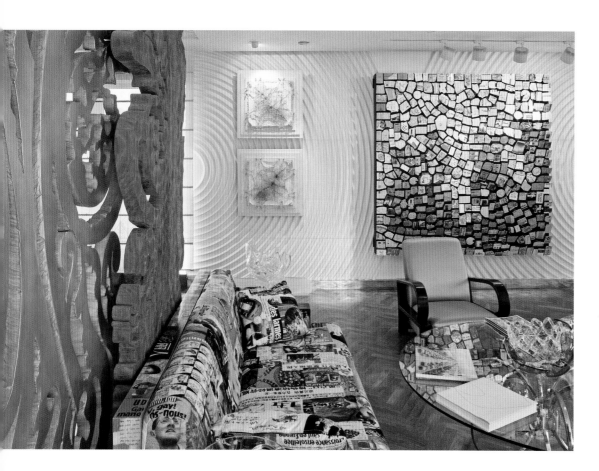

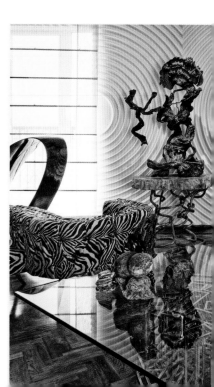

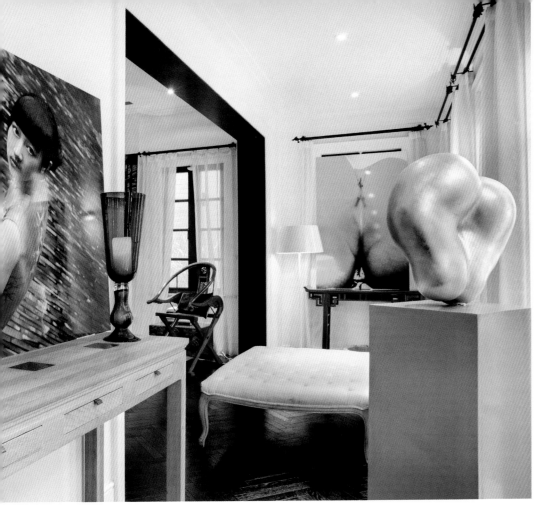

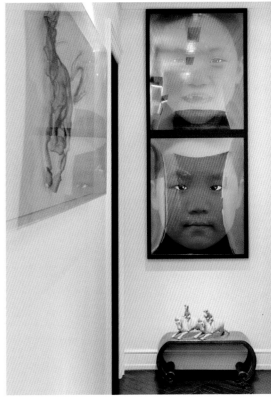

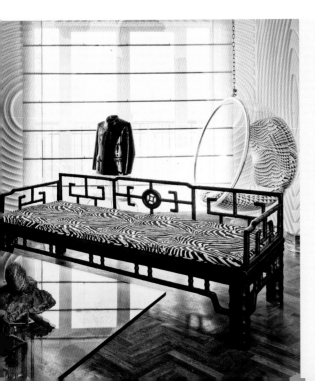

Opposite Pearl Lam's penthouse apartment in Shanghai's Xuhui district is as much gallery as home. At one end, a sofa by Mattia Bonetti is embroidered with images from magazines and pop culture.
Left Towards the other end of the double-length Pearl Lam apartment, a black 'Mao Jacket' fiberglass sculpture by Sui Jian Guo stands behind an antique open-back daybed upholstered strikingly in a zebra stripe fabric.

Above left The Art Deco 1930s house of gallery owner and collector Elisabeth de Brabant, in the French Concession, Shanghai. The two photographs and silver sculpture at right are by artist Wang Xiao Hui.
Above On the upper landing of the de Brabant house, two portraits in the 'Red Child' series by Wang Xiao Hui provide a strong visual stop to the corridor.

Left In the Beijing house of artist Shao Fan, one of his best-known works—a deconstructed Ming chair 'exploded' and held together with acrylic panels—sits against a courtyard window.
Below An ironwork tree with hanging bulbs is 'planted' in a bed of pebbles in the Beijing apartment of Hong Huang. The apartment is a converted warehouse in the 798 art district.

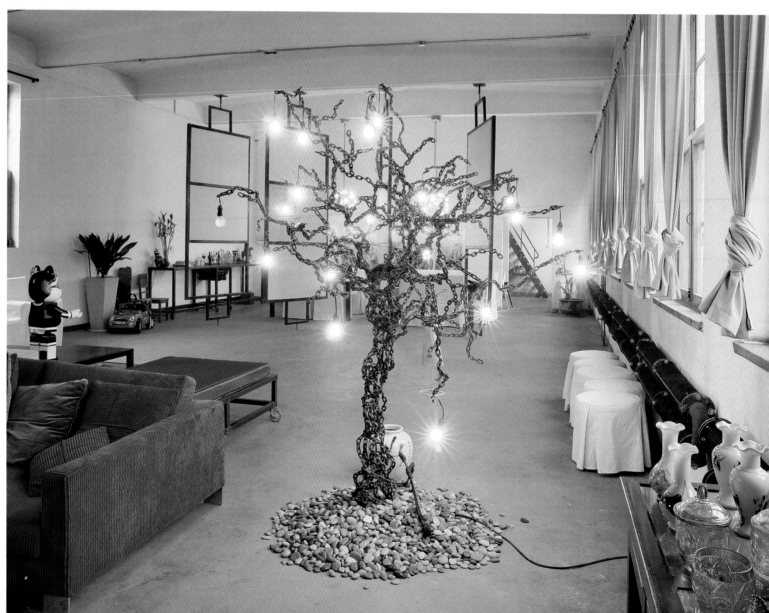

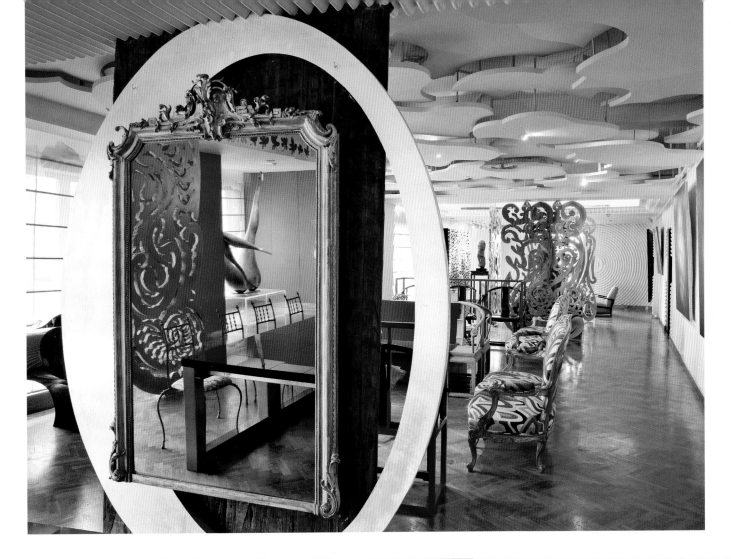

Above Another view of Pearl Lam's Shanghai apartment. Much of the furniture and fittings have been specially commissioned or designed by Ms Lam, including this divider that combines an antique Chinese door, a European gilt-framed mirror and an aluminum oval cut-out.

Left Seen across the dining table of a Shanghai apartment is a sculpture by Kunming-based artist Luo Xu, titled 'Eastern Venus', in resin, pigment and fiberglass with antique Golden Lotus shoes.

ENTRANCES AND LIVING SPACES

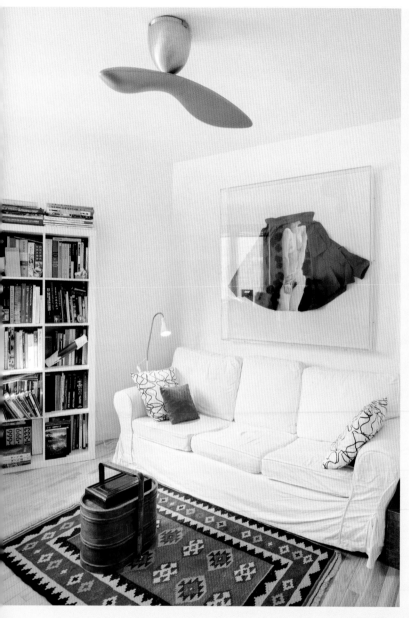

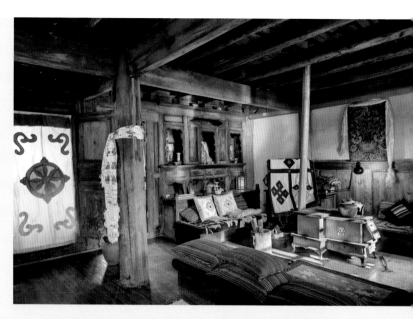

Above An authentically Tibetan living room in a house in Zhongdian, northern Yunnan, with added soft furnishing on seating arranged around the iron stove, the centerpiece for most households in this often-cold area.
Right Jewelry designer Jehanne de Biolley and her actor-designer husband Harrison Liu have made their Beijing home by converting a Ming temple close to the Drum Tower, and have maintained the red lacquer scheme of the posts and beams.

Above A simple white-upholstered sofa and geometric rug create a cozy space for reading and relaxing in a modern Shanghai apartment. The painting is by Wang Qiang. On the floor are green packing boxes from glass studio Liuligongfang.
Right The small apartment of Chinese architect and designer Zhong Song in Beijing stays comfortable with its choice of soft furniture. The sofa doubles as a desk and storage for a projector and speakers; the blind doubles as a home cinema screen.

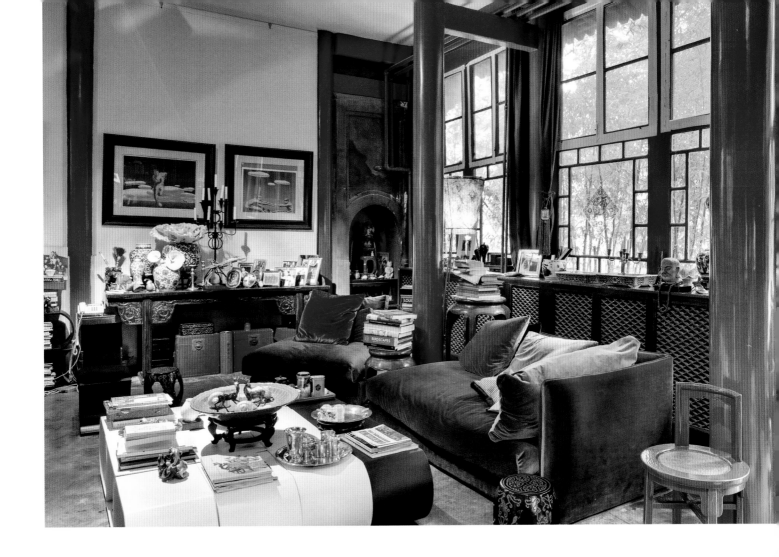

CASUAL **COMFORT**

A feeling of welcome, soft comfort and, above all, livability remains for most people a key priority, and here the Asian decorative techniques have much to offer. Comfortably upholstered seating is at the center of this, as in the examples shown here, but also playing a major role is the visual and the tactile, such as a generous use of unfinished wood, simple white as we have just seen, and intelligent application of natural lighting that casts gentle shadows. Natural wood, in fact, dominates much of the Asian style of decorating; it is often polished to an almost mirror-like shine. Lamps come in many forms, as we will see later, in Chapter 4 (page 100), and are decorated with either luminous shades or translucent quality stretched paper, bamboo and marble. Bringing into the space favorite objects—antiques, statuary, rugs, collectibles and so on—provides another form of comfort and interest.

Below Designed by Zhang Zi Hui and Chen Yi Lang, the conversion of a four-bedroom space into a single-bedroom home allows more area for entertainment, study and living. Sliding doors decorated with paintings give access to the bedroom facing.

Bottom Natural wood with slatted panels combines with white fabric to create a warm yet unfussy atmosphere in a small space, here separating the larger living area from the small kitchen.

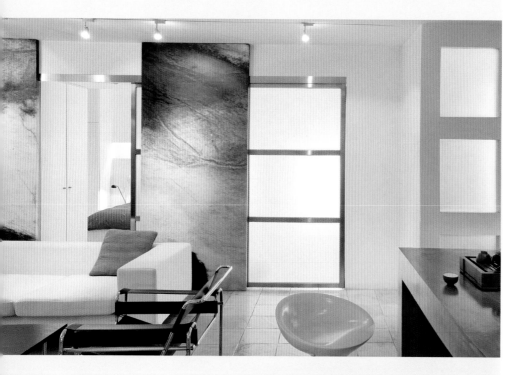

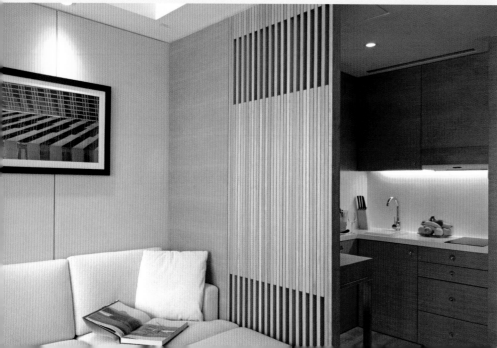

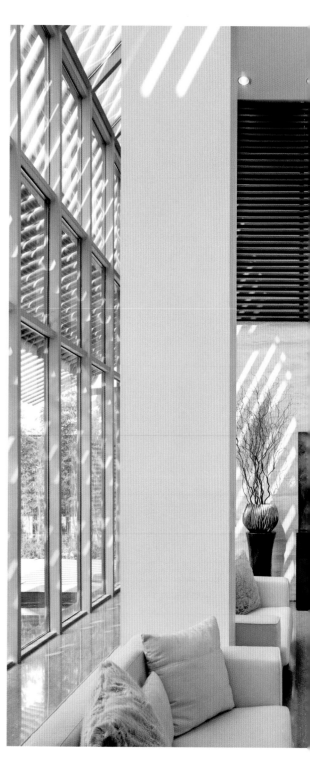

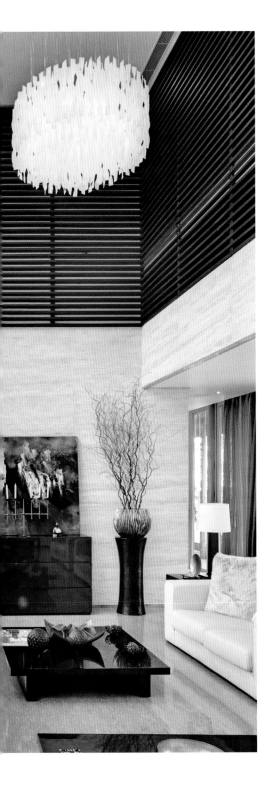

CONTEMPORARY **LIVING SPACE**

In 2003, the founders and real estate developers of Soho China, Pan Shiyi and Zhang Xin, were instrumental in kickstarting contemporary Chinese villa architecture and design by inviting a number of architects, including from other Asian countries, to work on a string of new villas. The modern style broke with the currently popular European neoclassical style, and since then the Chinese have been finding their own contemporary living style. With a booming economy has come the means and the confidence to develop an independent lifestyle identity, one that is no longer so reliant on the past, especially a Western past. The principal aesthetic has been one in which simplicity is emphasized in design as a way of expressing the nature of Chinese contemporary, leading people to seek more significance and spirit within the quality of simplicity. This contrasts with earlier aspirations of possessing a house with heavy and complicated decoration. The move that began just a decade ago with villas—to be expected because of the willingness of more wealthy home owners to experiment—has now spread to apartments and other, more affordable housing. Contemporary Chinese architecture and interior design is now in full flow.

Left A double-height villa in the grand style, designed by Rocco Lim. Windows cover one entire wall, while slatted 'eaves' outside filter sunlight.
Top An imaginative conversion of one floor in an old Shanghai lane house runs utilities and storage units in a kind of armature that interpenetrates the apartment. The wood paneling also serves as bench seating.

OPEN-PLAN **LIVING**

Just as modern interiors and the domestic architecture that supports them can be traced back to one key point—the commissioning by developers Pan Shiyi and Zhang Xin—so the now popular trend towards open-plan living started with Taiwanese architect Deng Kun Yen, some of whose work can be seen here under Contemporary Scholar's Studies, Lighting and Contemporary Courtyards. His reconstruction and conversion of warehouse and industrial spaces near the Suzhou River in Shanghai became enormously influential. It involved re-examining ways of living, away from the traditional and protective idea of a number of enclosed rooms with individual functions, and a willingness to participate in the new. It also involved the regeneration of old architecture. Developers are now recycling old buildings and making them useful once again. These buildings commonly feature large open spaces, often with big windows, high ceilings and exposed duct work. Factories and warehouses, when well-renovated and designed, have an incomparable openness and unique style, and loft living has rapidly and recently become popular. Additionally, they often have interesting architectural features, such as moldings, that help to make these large spaces distinctive.

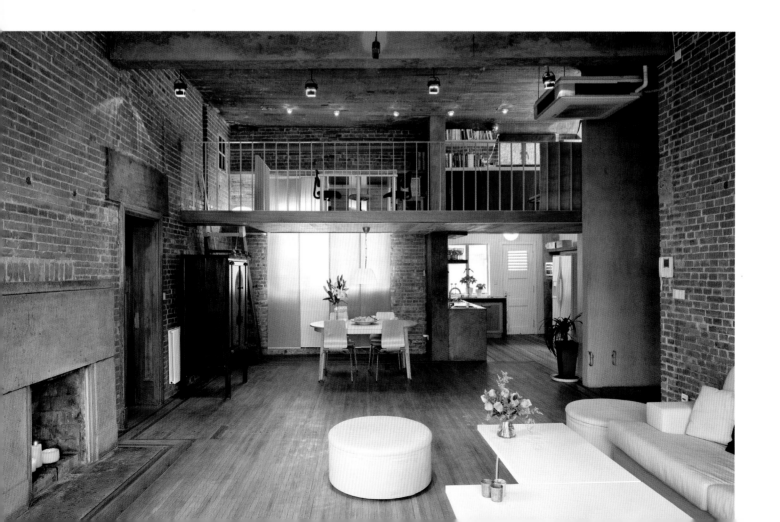

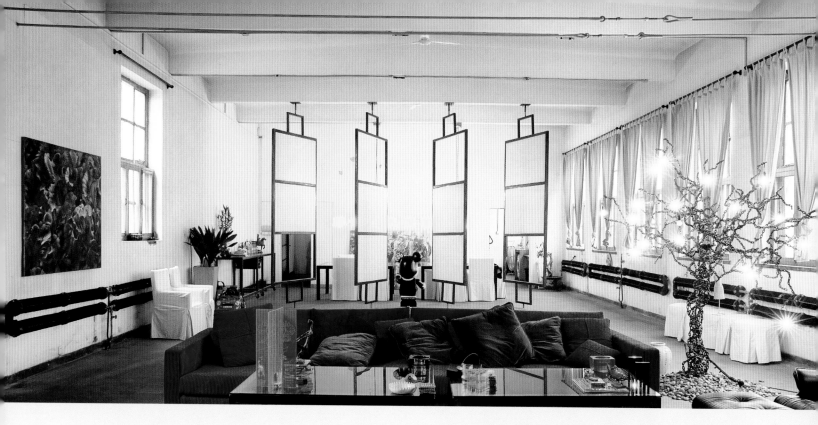

Left An open-plan conversion of a 1930s brick apartment in Shanghai. The exposed original brickwork and natural wood floor contrast with the simple, mainly white modern furniture. The new mezzanine carries a study and relaxation space.

Below A contemporary Shanghai apartment with a minimalist white theme, the living area on the left and the dining area on the right.

Above An apartment in the 798 Beijing art district, converted from a Communist-era warehouse. Four rotating iron-frame screens, each constructed of three canvas panels, separate the dining from the living area.

Below Demolishing interior walls in this Beijing apartment created a long, rectangular living room. A copper-clad wall is the surround for the television in a freestanding central unit that provides the focus for the open-plan space.

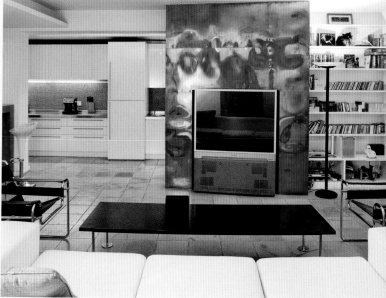

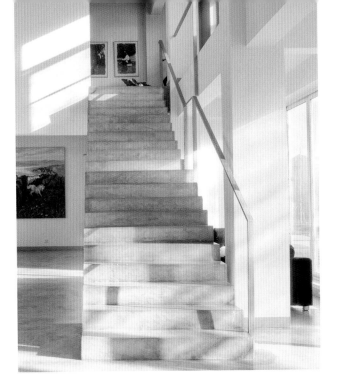

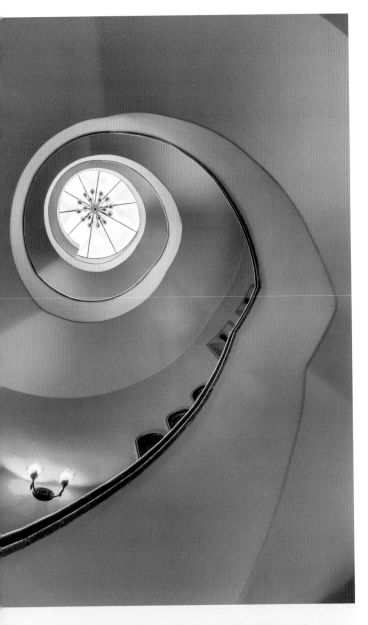

Above The elegant 1930s spiral staircase in the Pei family home in central Shanghai, seen from the entrance lobby.

Top right An open-sided white concrete staircase in the functional, spacious house of Beijing artist Yue Min Jun, well-known for his smiling man paintings.

STAIRCASES

Staircases the world over carry the potential for much more than mere access to an upper or lower level, and China is no exception. The tradition may be limited, and perhaps overly influenced by Western style, particularly in Shanghai, but with an increasing openness to domestic living, as we just saw under Open-plan Living, the staircase, when left—or built as—exposed, has an aesthetic and even sculptural role to play in the modern house. The major issue and real limiting factor in a domestic space is the lack of volume with which the designer or architect can play, but in the modern way with staircases much can be done to give them real presence, as the striking red and black construction at top right confirms—an entirely original and organic solution to opening up a traditionally narrow terraced lane house. As a key design element in a house, the best staircases reflect their owner's taste and current fashion, beginning, strikingly, with the 1930s spiral design at left, in a Shanghai mansion. Concrete, steel and glass, wood, marble—all these materials are being put to use. The owner of one restored Art Deco house over-leaf even takes the opportunity to make a stairwell into art, as a giant reproduction of the painter Henri Rousseau unfolds over three stories.

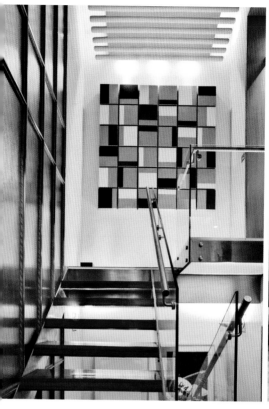

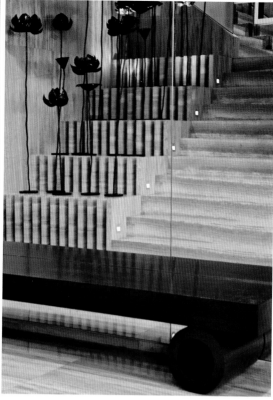

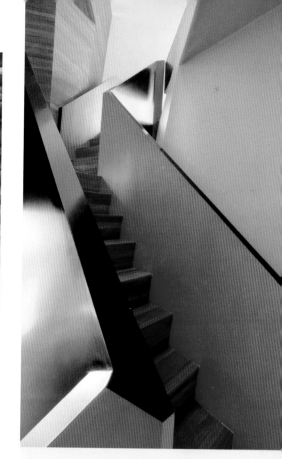

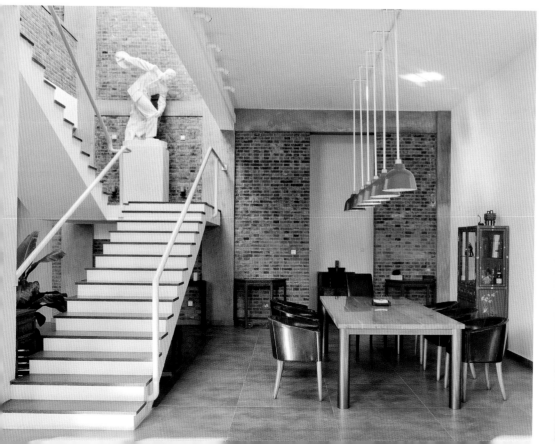

Above left Glass, wood and steel create a visually light geometry for the central staircase in the house of Shanghai-based designer Kenneth Jenkins.

Above center Seen here in a wall mirror behind a contemporary bench, sculptured lotus flowers rise in tandem with the steps of this broad Hong Kong staircase.

Above In the conversion of a Shanghai lane house for owner Fred Kranich, the original four stories have become eight staggered levels. The staircase was created on-site, weaving eccentrically around the different levels and rooms of the house.

Left The open staircase in the home of Beijing artist Sui Jian Guo, designed by neighbor and fellow artist Shao Fan, doubles as a display area for one of his well-known sculptures, 'The Discus Thrower'.

ENTRANCES AND LIVING SPACES

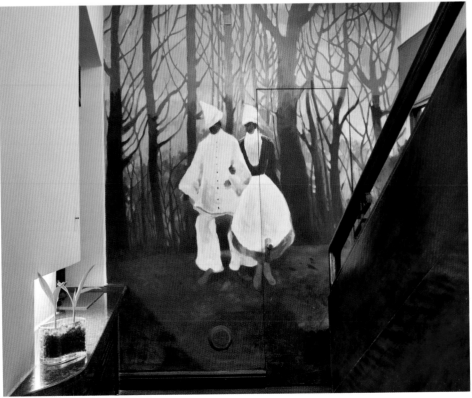

Left and below The owner of this small three-story French Concession house, who was responsible for its restoration, reproduced a tall Henri Rousseau painting, 'Une Soirée au Carnaval', on the three successive landings.

Opposite above left In a Shatin two-floor apartment in Hong Kong, designer Anderson Lee built substantial storage space into one side of the stained wooden staircase.

Opposite above right In the entrance area of a large contemporary residence on the outskirts of Beijing, the open-sided staircase becomes an architectural element, rising above a central pond and behind the unpainted brick wall.

Opposite below left The narrow and formerly dark stairwell in a small French Concession house has been opened up and lightened by painting all the woodwork in white, and setting it against the raw surface of gray handmade Chinese bricks.

Opposite below right Painted completely in white, a spiral staircase rises through this study area, making a striking contrast with the strong red walls and ceiling.

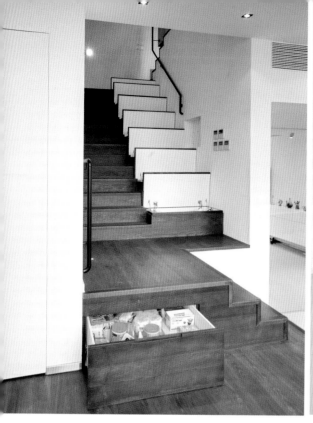

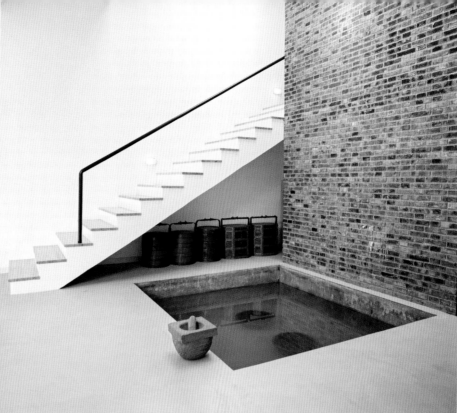

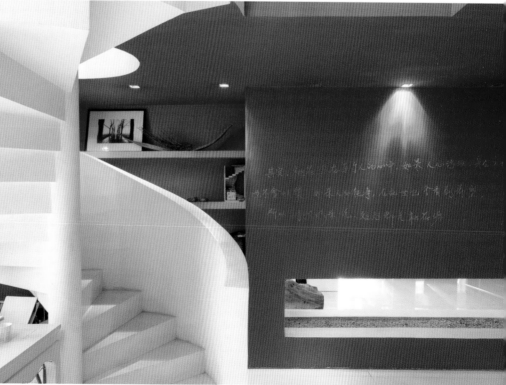

ENTRANCES AND LIVING SPACES

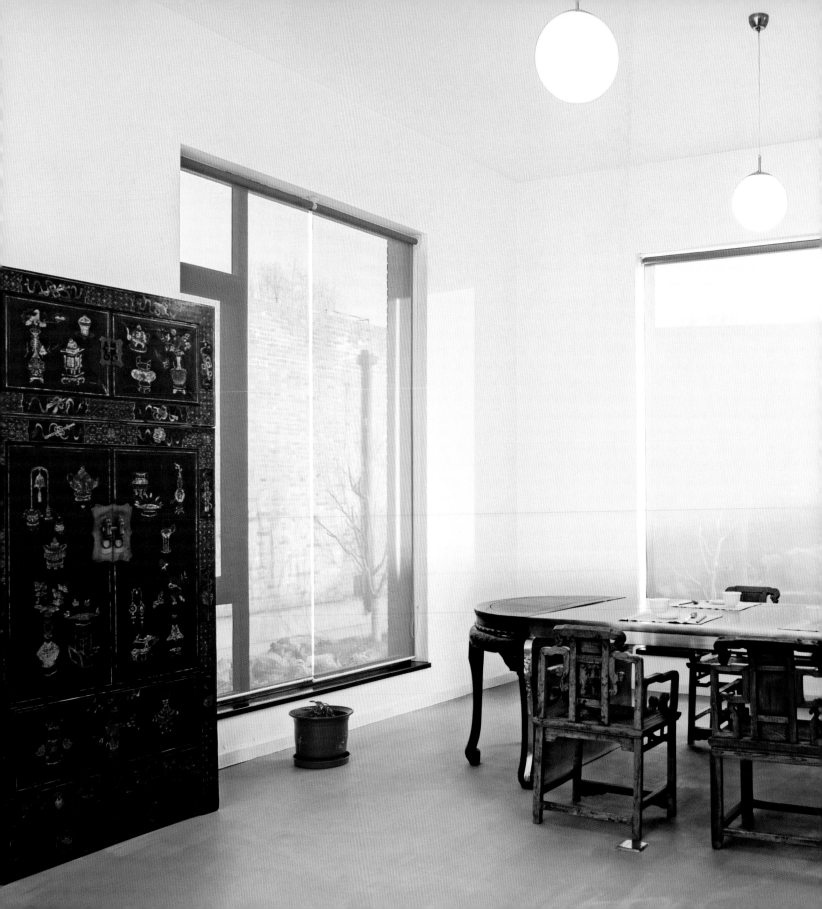

DINING ROOMS, KITCHENS AND STUDIES

The dining room is the key space in the home that is not only focused on interaction between people but centered around an event. In homes where entertaining guests is important, it lends itself to the idea of occasion. Even in smaller dwellings, it still functions as a space that comes to life at particular moments of the day, because the Chinese rarely, and never by preference, eat alone. Communal dining is, in fact, the traditional norm in Chinese culture, as evidenced by the cuisine, which is based on shared dishes rather than plated meals, and on the archetypal large circular table that facilitates open and equal conversation. This particular archetype may no longer be the most common in contemporary home design because the changing sizes and distribution of residential spaces tend to favor more rectangular tables, but the legacy of dining as the place and occasion on which to concentrate hospitality to guests remains.

Within this basic form of a table large enough to seat several people and accompanying seating, there is, as we might expect, plenty of room for personal expression, from traditional to minimalist to modern, and from 1930s retro to experimental fusion of Western and Chinese. Notable also is the contemporary trend towards eating less formal meals in the kitchen, which allows even more room for innovation in layout and furniture. This has the added effect of drawing the kitchen into the design concept of the whole home space, and elevating it as a room on which to lavish attention.

Another place for expressing personality and preferences is the study area. This is not a completely essential room, and that alone gives it a special and intimate quality because this is a place for the mind and soul. Moreover, it has a particular significance in Chinese culture because it inherits the tradition of the scholar's study as a place for reading, learning and for cultivating oneself through meditation. Such formality is lightened in today's world by including music and television.

The calm elegance of a dining room that blends traditional and contemporary in more ways than one. The cabinet and chairs are antique, the building itself new, though designed on courtyard house principles, while the table, by artist Shao Fan, is a striking fusion of wood and steel.

MODERN **DINING**

Chinese food is typically associated with festive and convivial environments and mealtimes tend to be more extrovert and boisterous than in the West. The dining space in more and more Chinese houses has been raised to become a focal point that reflects the taste, lifestyle and hospitality of the owners. There is innovation not only in the space itself but also in the furniture. A leading light of the new generation of designers for the home, Yu Yongzhong, with his Shanghai-based design brand Banmoo, is one of several who are redefining the materials of dining, drawing more on Chinese stylistic traditions than on Western. In contrast to the traditional dining space where the dinner is hosted at a round table with ornate furnishings in bold red and gold hues, the modern approach is addressed with a long table, flat cabinetwork in materials such as lighter woods, glass and stainless steel. Increasingly, the floor plan shows a tendency for the dining area to be at once separated from the kitchen but visually connected to it. This reflects a general trend in modern living towards openness. In this way, the dining area becomes a linking or transitional space between kitchen and living area. It thus serves as a gathering place for not only dining but also for communication.

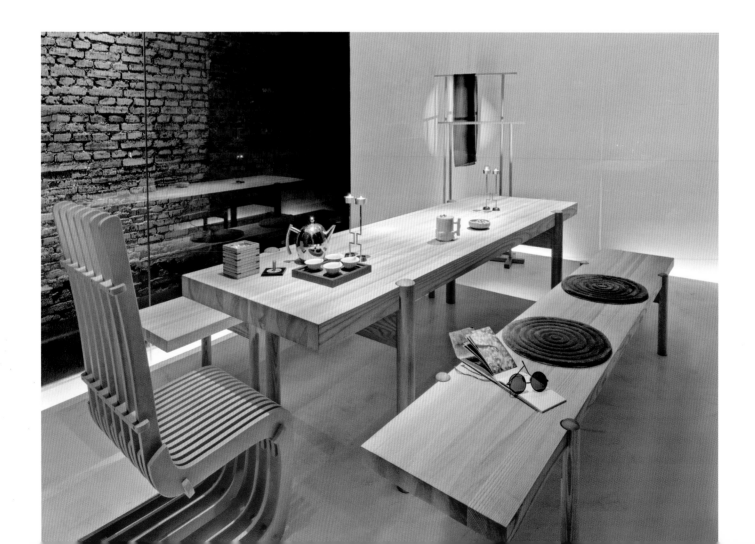

Opposite The dining room furniture, created by up-and-coming design brand Banmoo, brainchild of designer Yu Yongzhong, comprises a refectory table with bench seating and coiled-rope cushions, and a high-backed slatted wood chair.

Right A dining room in a Pudong villa, with a serving hatch to the kitchen behind.

Below High-backed chairs and a spacious room help create an understated but elegant dining area.

Below right The kitchen dining area in the same villa has a simple long table between the workspace and window.

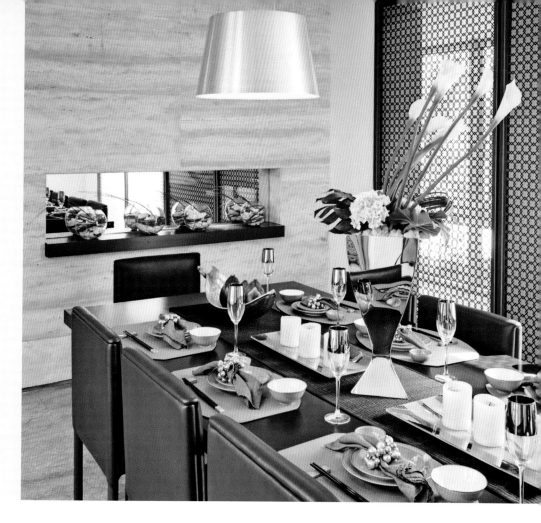

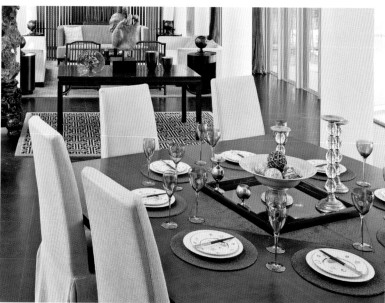

Above The food preparation area in this light and airy house near the Great Wall, designed by Japanese architect Shigeru Ban, leads to the dining room beyond.

Right In a conversion of a terraced lane house in Jing-an, Shanghai, the rear, which has become the designated dining area, opens out to a small garden.

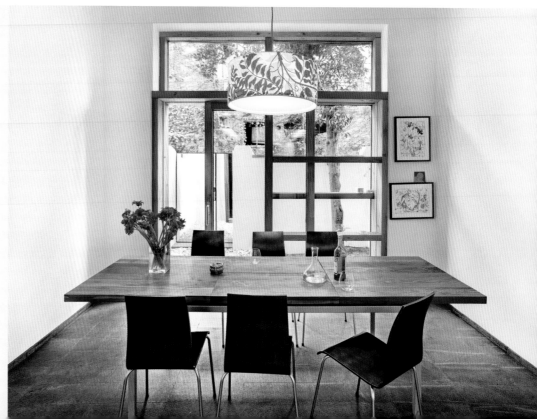

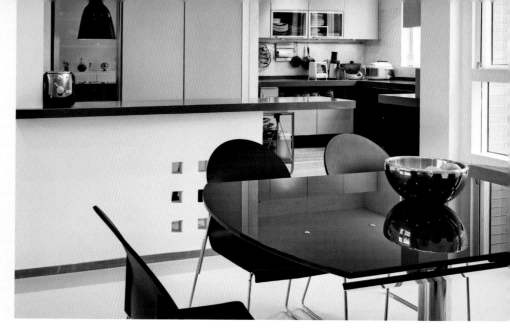

Right A light-framed table and chairs adjoin the kitchen in a Hong Kong apartment designed by Anderson Lee.

Below The open-plan downstairs room in artist Ai Weiwei's home, with its long table, is both a meeting space and a dining room.

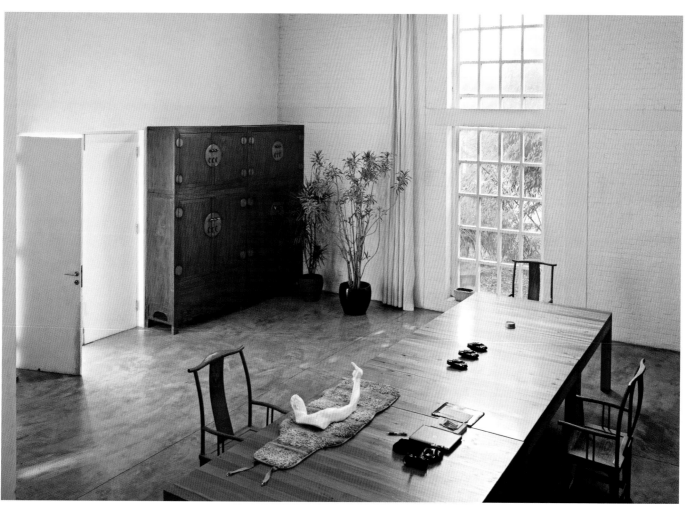

Below The dining room of a villa in Fuchun, near Hangzhou, designed by Belgian architect Jean-Michel Gathy, references traditional Chinese post-and-beam construction.
Top right French/Chinese place settings add charm to the dining room in Laetitia Charachon's Shanghai *longtang* house.
Center right A painting by Chinese artist Shu Jie, 'Small Eyes Over the World, Pistol', 2008, overlooks the dining area of the Bouillet House in Shanghai.
Below right A 1930s dining table and furniture from Shanghai complement the contemporary white cotton upholstery in an Art Deco-styled apartment in Singapore.

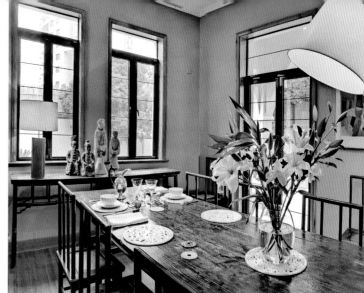

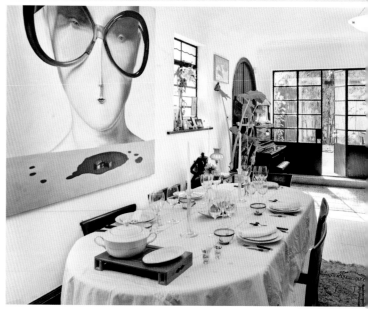

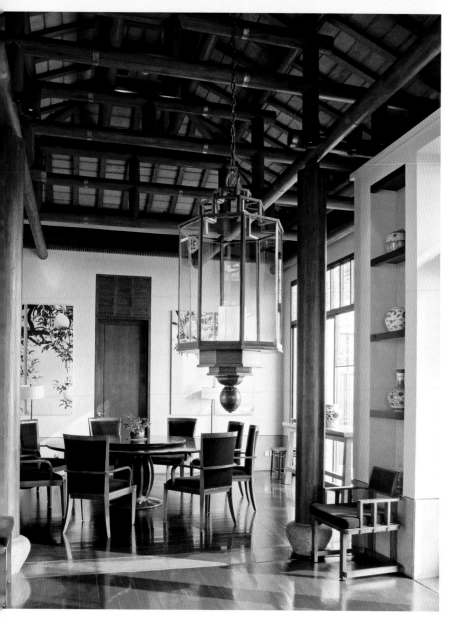

FAMILY **DINING**

In most homes, naturally the majority of mealtimes are without guests and are not formal. Many Chinese dining spaces are integrated with the rest of the house in such a way that they are not just for dining, but serve also as places to relax with family and friends. The table becomes a more communal and mixed-use piece of furniture. The design is normally straightforward and modest, perhaps with retro touches and family memories, with an emphasis on comfort and convenience for an area that sees frequent use. Family dining spaces tend to have in common a sense of striking a fine balance in the combination of traditional and contemporary designs. Ultimately, they have to function as a family hub, expressing a feeling of warmth and unity. Perhaps even more genuinely than formal dining rooms that aim to showcase a certain style and flair to guests, family dining spaces reflect in their decoration a true sense of the owner's personality and preferences.

A family dining table and a counter bar for more casual eating by the kitchen flank steps leading up to a roof terrace in a two-level Hong Kong apartment.

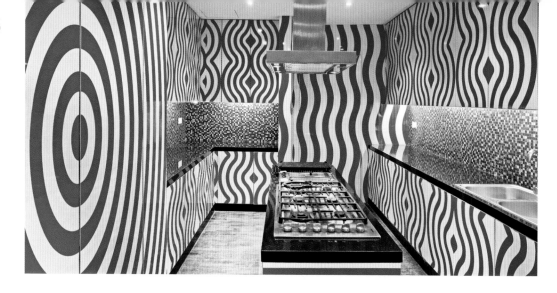

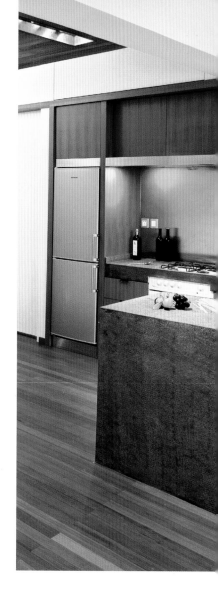

CONTEMPORARY **KITCHEN STYLE**

The interior design of kitchen space in many Chinese homes is evolving towards the contemporary, parallel with the overall trend in contemporary living. Now we can see a modern style of Chinese kitchen, projecting the fact that nowadays living itself in China is becoming a busy and ultramodern affair. Even though the kitchen is typically a small space in Chinese houses, and traditionally of lower priority than other rooms in terms of design, being functional and generally hidden from the view of guests, it is at last receiving design attention and beginning to show diversity and innovation. Here, the influences are distinctly Western, where kitchens have already transitioned from a backroom utility mentality to the focus of attention and, inevitably, expenditure. People now simply spend more time in kitchens, and in the case of open-plan designs in small apartments and small houses kitchens are open to inspection and approval from guests. We can also see influences being drawn, in particular, from sleek Scandinavian and German styles, with modern surfaces and finishes and a general sense of tidiness. Appliances and kitchen gadgets tend now to be showcased rather than hidden.

Top This striking kitchen is decorated in a bold design taken from Op Art, the red and white walls contrasting with the blue recessed workspaces.

Right In a lane house conversion, the ground floor open-plan kitchen area is built around a central staircase and cupboard unit, extending to a dining area beyond.
Center right This kitchen in a French Concession house has suspended dark paneled cupboards, with concealed lighting underneath.

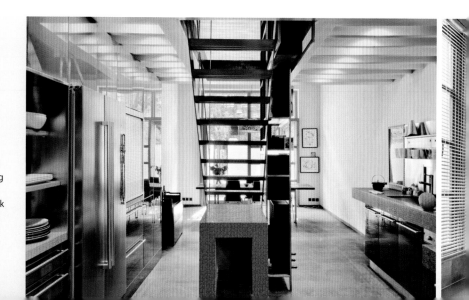

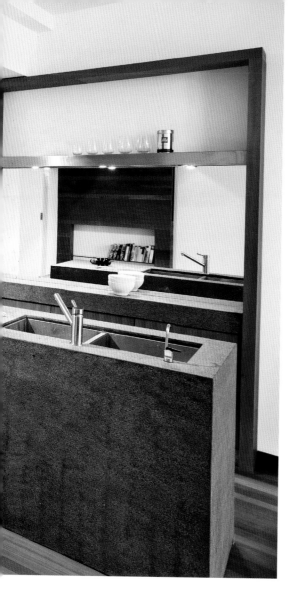

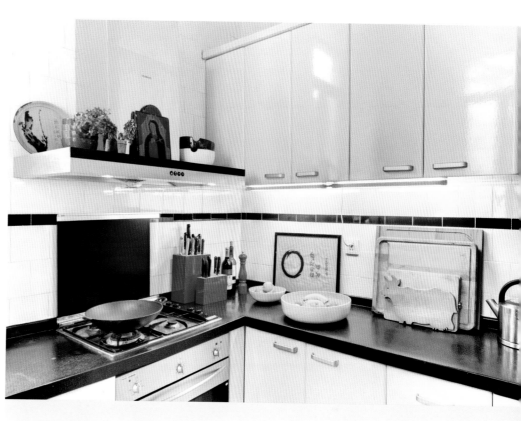

Left A freestanding sink and food preparation unit, clad in granite slabs, is the centerpiece of an open-plan conversion of a small studio apartment in a Shanghai block.

Above and below An unusually spacious kitchen for a Shanghai *longtang* house combines Western storage and preparation convenience with facilities for wok cooking.

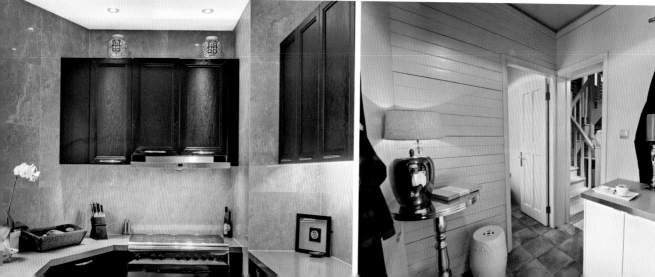

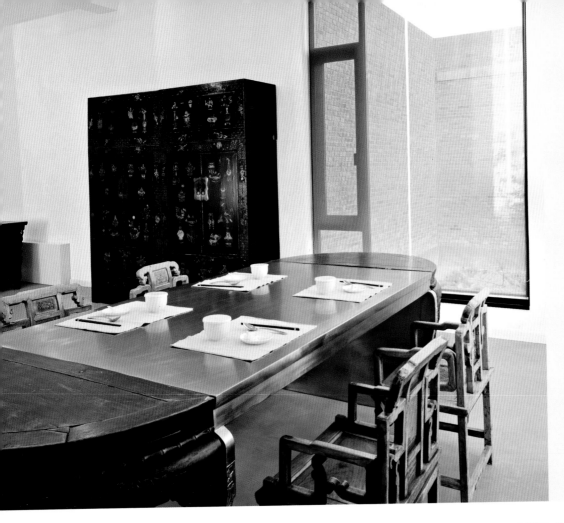

Left Shao Fan both designed this house for his friend and neighbor and furnished the dining room with a table that is a functional work of art, made by fusing two wooden side tables with a stainless steel rectangular center section. The black lacquer cabinet behind is Qing dynasty.

Below left A detail of the traditional cabinetwork that went into the table on the opposite page, applied to both wood and Perspex/Plexiglas sheeting. Below A U-shaped 'Tiao'an' in one living room. This traditional type of narrow side table is normally rectangular in shape, but Shao Fan challenges the accepted convention with this three-legged interpretation.

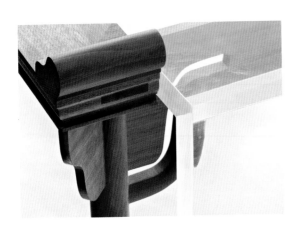

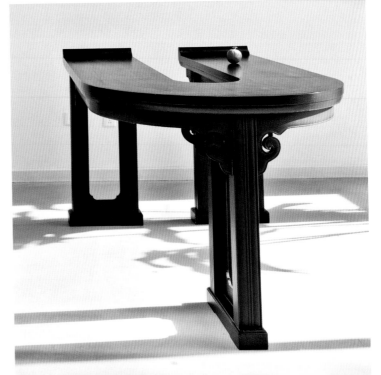

THE DINING ROOM
AS ART

The artist Shao Fan, whose home appears elsewhere on these
pages, embodies a modern classical spirit that is a little unusual
in contemporary China. Not only does he believe strongly that
China's art and style must be inspired by its own traditions rather
than those of the West, but his works, which are immensely varied,
ranging from architecture to painting, importantly include furniture
pieces. These, such as the tables shown here, are at the same time
completely functional and yet provocative works of art. Shao Fan's
method, which he has made very much his own, is to deconstruct
either original Ming pieces or versions manufactured to the same
high standard of cabinetwork in his workshop, and insert and attach
functional sections from modern materials such as steel and acrylic.
On one level, this deconstructing of furniture in the Ming style and
combining it with contemporary materials and design, expresses
philosophical and cultural changes in Chinese society, while associ-
ating our memory and behavior with Chinese dining etiquette. But
on a deeper philosophical level, we have to confront what the artist
calls "the inherent drama of the incompatibility of their parts". By
creating works that are also beautiful pieces of furniture intended to
be used in a normal way, the artist subverts the users by increasing
attention over a long period on the inherent irony and discontinuity
of modern China.

This table, made entirely in the artist's workshop, is in the Ming style, with
everted flanges, but is constructed from both wood and Perspex/Plexiglas
in a traditional cabinetwork manner. It represents the conflicts faced by
contemporary Chinese in accommodating tradition and modern life.

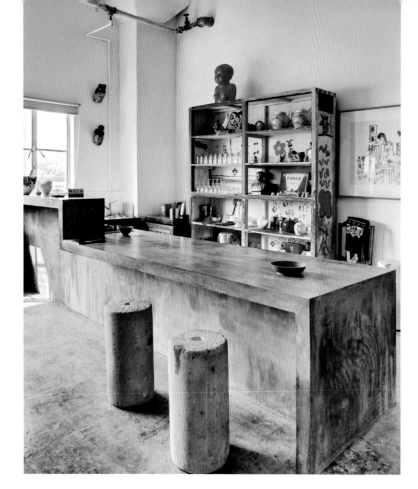

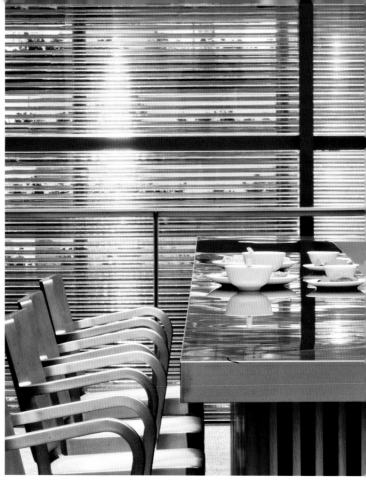

KITCHEN **DINING**

As the kitchen is becoming a more visible and used space within the modern home, by extension it is now used more and more for informal meals and not just breakfast. On one scale, because kitchens now have design attention paid to them and are consequently becoming relatively attractive places in which to spend time, there is a convenience value in counter dining—a trend found in restaurants and made more acceptable because of it. It is also a great place to enjoy morning coffee with a neighbor, friend or family member.

At the same time, with the general move towards open plans, the line is becoming blurred between kitchen, dining and living. Casual furnishings are becoming increasingly popular, with comfortable and stylish decors available in styles to fit every personal taste. Casual furniture choices maximize comfort and utility, while eliminating complex details and fussy accessories. Simply upholstered chairs and stools, and rectangular or curved bar tables, are common features that give these areas a casual and intimate atmosphere.

Linear dining as part of a kitchen area involves family members in cooking together. Rectangular tables tend to offer a better fit for a narrow room; and can become like a central island in enhancing family unity.

Far left Cylindrical stones are used as stools at the concrete counter of this kitchen in the studio apartment of collector and gallery owner Li Liang. Artworks behind include a bust, 'Miss Mao', by the Gao Brothers, and ink-splattered shelving by Zhu Xing Jia.

Left A steel-topped counter breakfast bar with aluminium chairs in the penthouse suite of the Z58 building, Shanghai, designed by Japanese architect Kengo Kuma.

Right In the kitchen of the small apartment of designer Zhong Song, gray wood-covered storage units surround the cooking/sink area on the left. The eating counter is on the right. A centrally pivoting door opens onto the living area beyond.

Below The kitchen/dining area of artist Sui Jian Guo's Beijing house, with a worktop that doubles for food preparation and eating.

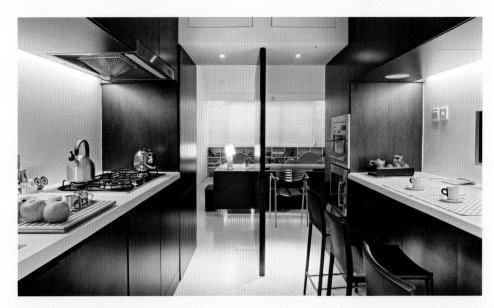

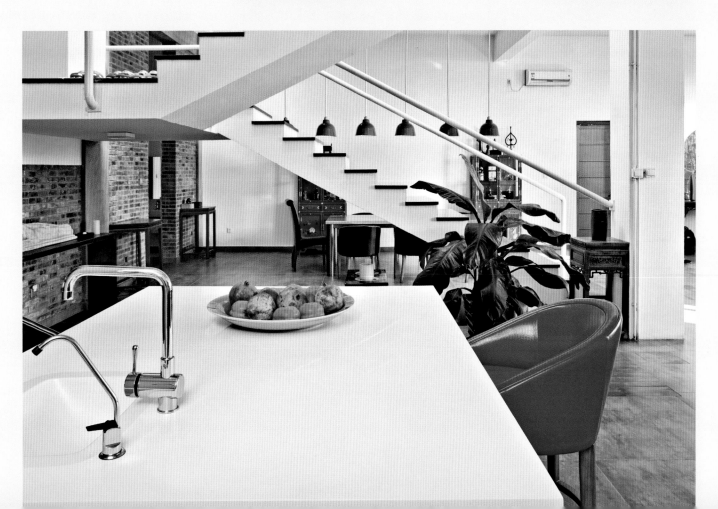

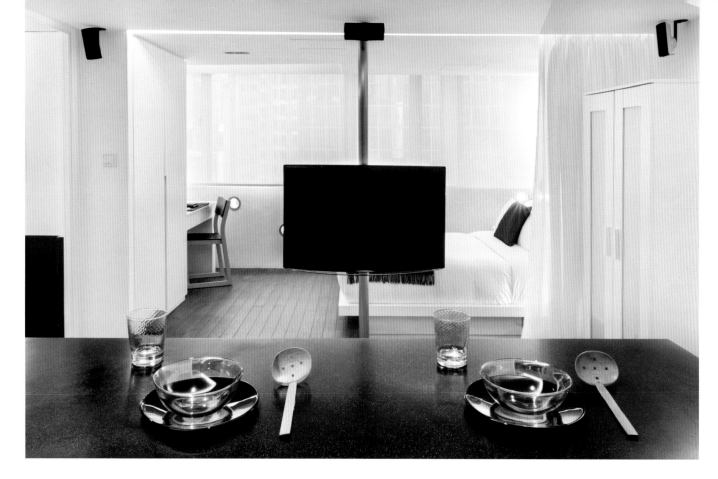

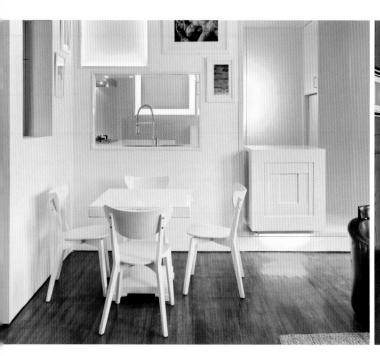

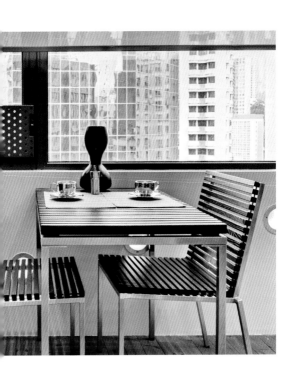

Left A glass-topped kitchen table used for eating as well as food preparation, with a central tap which pours into an inset glass bowl basin that drains through the unit.
Opposite above A kitchen counter set for noodles in a studio apartment in Causeway Bay, Hong Kong. The swiveling television on a steel pole allows viewing from either the sitting area or bedroom.
Opposite below left The modern conversion of an apartment in Shanghai's 1934 Hamilton House makes extensive use of white to lighten the apartment, while concealed lighting 'lifts' kitchen units.

Opposite below center A marble-clad central kitchen unit, with upholstered steel stools, serves for breakfast as well as casual dining.
Opposite below right Kitchen dining for two in a small Hong Kong studio, with wood-slatted, aluminium-framed table and chairs.
Below This kitchen eating area of a Shanghai *long-tang* house has unusual height and original 1930s white tiles.

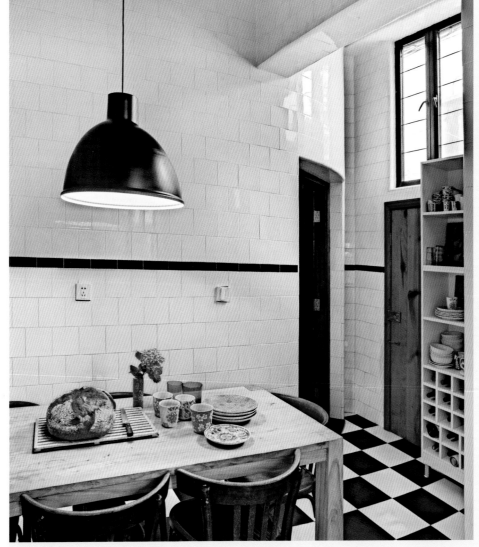

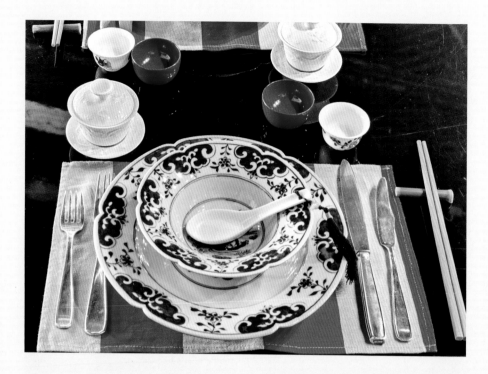

Left A combination Chinese and provincial French place setting in the home of Jehanne de Biolley and Harrison Liu.

Below left The dining table in one of gallery owner Pearl Lam's apartments, decorated by Cyril Gonzalez with frog-and-feather brooches and jade chopsticks.
Below center A plain white service makes a simple contrast to the rich colors and 'cracked-ice' openwork wall decoration in the dining room of a converted Beijing *hutong*.
Below Detail of the place settings in the dining room shown on page 54 top right. A notable feature is the use of antique marble *yupang* as underplates on the natural wood surface of the table.

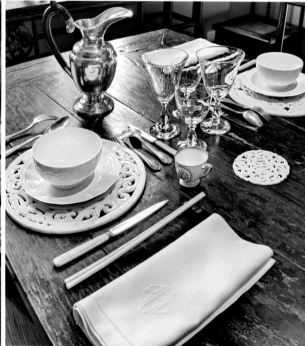

THE ART OF **THE TABLE**

Often overlooked is the care and thought that traditionally go into the place settings at a Chinese table. Dining in China is, as we have seen, a cornerstone of social interaction, whether with extended family, friends or guests. As a social occasion, the presentation of not just food but the settings are steeped in tradition and assume a particular importance. The traditional Chinese table decoration is meant to create a complex yet appealing balance of colors, patterns and textured objects, typically set against dark, solid wooden furniture. At the dinner table, the colors red, gold and green would represent happiness, health and family, and common decor items include ivory figures, porcelain vases, lacquered wood and potted bamboo. The curved lines, glossy surfaces, carved details and careful craftsmanship of Chinese furniture add an imaginative touch to a variety of decorating schemes. But of course, as in so much else in contemporary Chinese society, there is change, and one of the most notable is the incorporation of Western idioms. Imported wine, for example, is increasingly common in the context of a Chinese meal, and provision has to be made for this. Moreover, meals in many homes are beginning to feature fusion cooking, reflected in an intriguing design mixture in the settings.

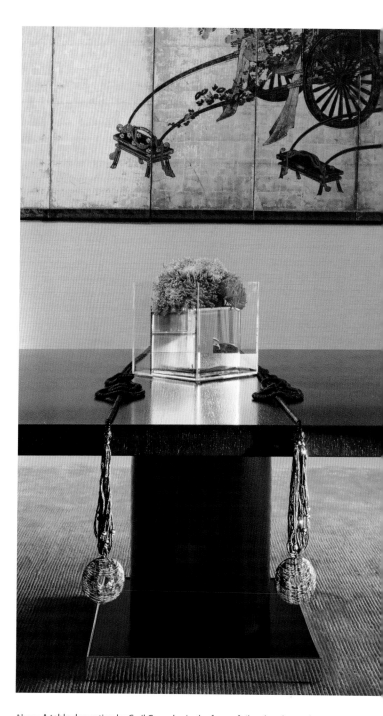

Above A table decoration by Cyril Gonzalez in the form of silver bead strands with metal pendants, inspired by Chinese *bi* (circular jade artefacts).
Left An innovative coffee table made from a polished aluminium aircraft wing.

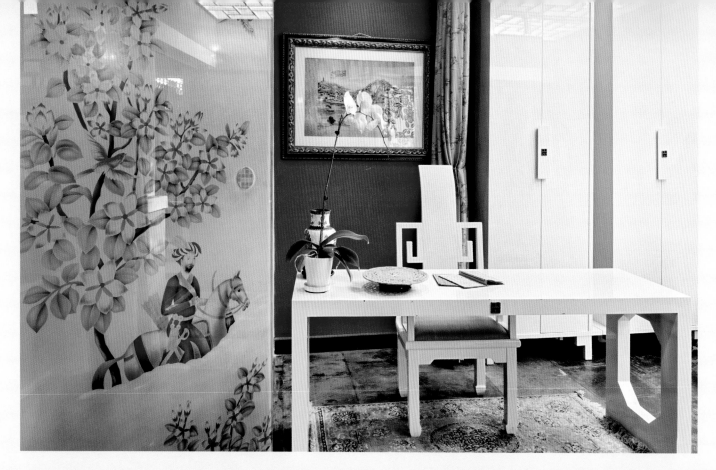

Below left In a classical Chinese-themed two-level apartment, a Ming table with stool is used as a desk in a quiet corner. Contemporary wall shelving blends with the simplicity of the Ming antiques.

Below right The library in the Manhattan apartment of enthusiastic collectors of Chinese furniture. A marble-topped mid-nineteenth century Chinese barrel stool made of *hong mu* wood provides occasional seating while browsing the bookshelves.

Above Plain white-lacquered furniture designed by Harrison Liu evolves classical Chinese themes, while the etched-glass wall in the foreground, painted with a Silk Road motif, adds an exotic flavor.

Opposite left Inspired by traditional designs, a desk and chair are lacquered bright red.

Opposite right An antique desk, chair and mirror in a Hong Kong apartment. The mirror was framed using a wooden carving originally from a Chinese wedding bed.

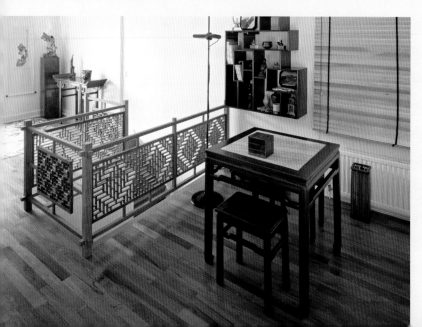

PERSONALIZED **STUDIES**

Shu zhai **is Chinese for 'study room', and has a place of special significance** even in contemporary China because of its legacy inherited from the traditional scholar's study that we see in some of the following pages. But whereas the formalized study of, say, a Ming man of letters, followed a prescribed layout and inventory of possessions and writing tools, modern studies are intensely personal places that suit the habits and needs of the owner. They can be entire and substantial rooms with library shelving, or simply a favorite or idiosyncratic desk and chair in the corner of a living space or bedroom. As the varied decors here show, anything and everything can be utilized, from modern furniture designed with playful but elegant reference to Ming styles, to an antique table. It matters only that the resulting work surface, space and ambience help to create an inspirational atmosphere for the individual.

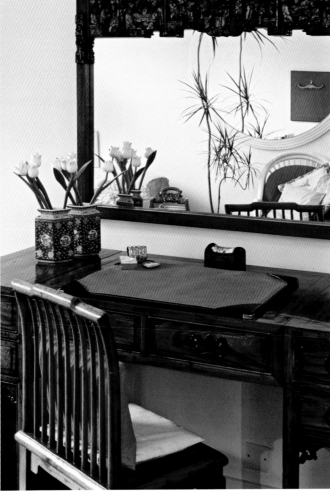

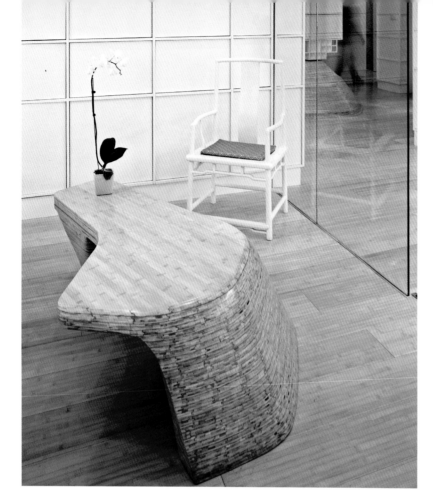
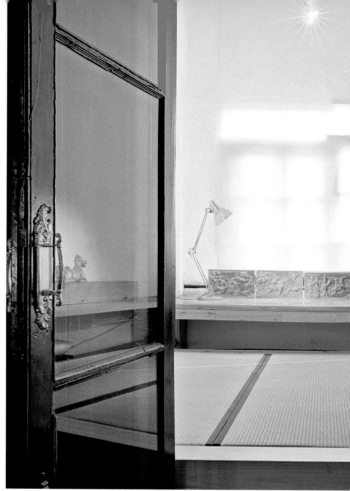

CONTEMPORARY **SCHOLAR STUDIES**

Though varied in their results, these four contemporary studies owe much to the tradition of the scholar's study, which we explore on the following pages. Study, and a dedicated place in which to pursue it, has a peculiarly strong and long tradition in Chinese culture. It was associated with the *literati*, with Confucian and Zen traditions, and is still accorded respect in those modern homes where there is sufficient space to accommodate such a room. The contemporary scholar's study room shows emotional reverberations of designs that are not immediately obvious, but are subtly revealed through careful contemplation. The furniture in the study room explicitly displays the beauty and aesthetic value of space, meanwhile conveying the persistence of study. In some cases, the aesthetic tastes tend towards simple and austere wooden furnishings without overly ornate details or patterns, which reflects the sense of orderly restraint that has much in common with Zen-inspired minimalism. Following this principle, the approach to interior design is somehow sharp and insightful. Here we have a range that goes from a furniture-less Zen simplicity to the more focused functionality of a painter's study. Painting and calligraphy were always, naturally, an integral part of the scholar's life.

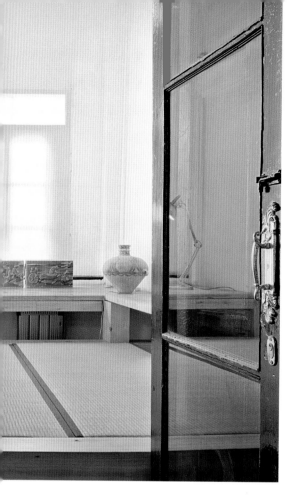

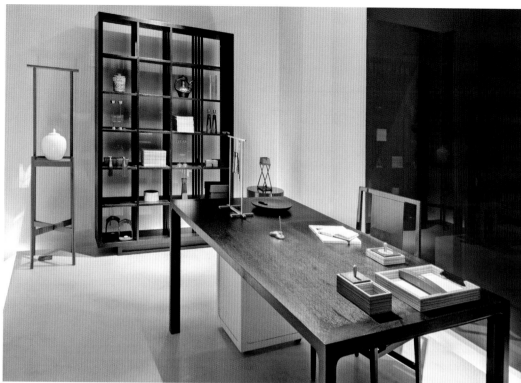

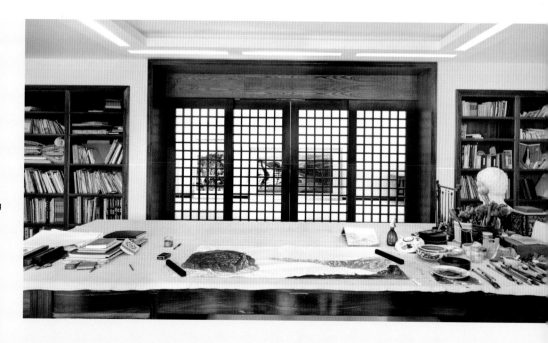

Above left A sparse, almost minimalist study finished in white paneled cupboard walls and natural wood. The desk is carved in a free-flowing shape from laminated wooden sheets. The white-painted yoke-back chair is a Ming reproduction.

Above For his own apartment in the former Japanese consulate in Shanghai, architect Deng Kun Yen removed the existing partitions of what used to be a terrace to create a raised study and meditation space, floored with Japanese *tatami* mats.

Above right A contemporary study in neo-Ming simplicity by designer Yu Yongzhong, with black-stained wooden desk, bookcase and display stand.

Right The studio of a Chinese painter who works in the traditional brush-and-ink manner on large-scale landscape paintings, which calls for a large waist-height painting table. Latticed sliding doors open onto the artist's gallery.

DINING ROOMS, KITCHENS AND STUDIES

TRADITIONAL **STUDIES**

The scholar's study occupies a central role in Chinese culture and has, as a result, had an essential impact on the architecture of the home. Among the literati (*wen ren*) it was a well-used place for reading and learning as well as for cultivating self through meditation. It embodied Confucianism (though in feudal society only men were entitled to learn) and so, long before schools, a study shouldered the responsibility of education and served as the shrine for education. In modern China, this symbolism gives the scholar's study a special, respected place. Traditional furniture is formally prescribed and focal to the arrangement, centering on a desk with chair and foot stool, and an array of containers and displays for scrolls (later books) and paintings. Traditional groupings include 'The Four Treasures of the Study' on the desk, 'The Four Books and Five Classics' on the bookshelf, 'Rare Gems' in the treasure shelf, and 'Calligraphies and Paintings of the Famous' in the scroll holder. These were considered necessary and useful tools of learning. A certain austerity pervaded studies such as the one in the main photograph here dating to 1797, in keeping with the ancient Chinese belief that a place of study required toil rather than relaxation, though this strict attitude has, of course, softened over time.

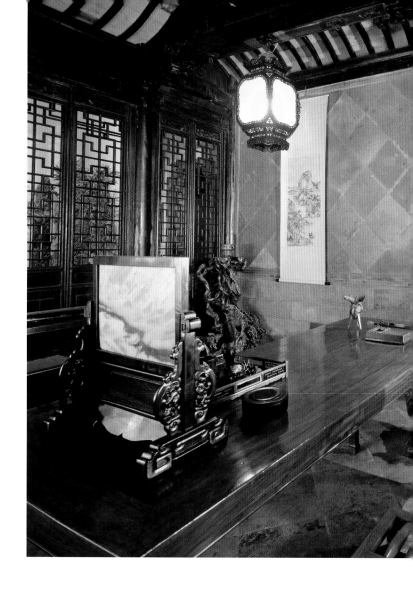

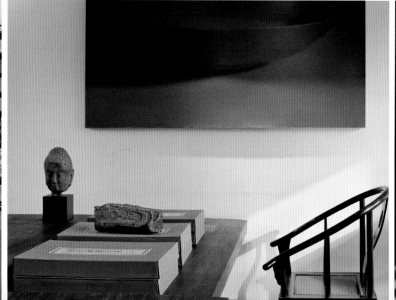

Far left Deep turquoise was chosen for this office to set off the rich tones of the classical Ming desk, horseshoe-back chairs and spindle-back settee, all made of *hong mu*. A *huanghuali* document box rests on a modern marble coffee table.

Center left An antique Ming horseshoe-back chair and heavy contemporary wooden desk below one of artist Shao Fan's black series paintings. One of the attractions of Ming furniture is that its simple, rigorous lines complement equally simple modern furniture.

Left A dark wooden desk in the corner of a bedroom blends discreetly with the paneling in this restored Shanghai house.

Above left An actual scholar's study from a Qing dynasty residence in Tangli, in the West Dongting Hills, reconstructed at the Minneapolis Institute of Arts in the United States. It features a plain large desk, foot stool and yoke-back chair. The decorative screen on the desk, which carries a stone with a natural landscape pattern, protected papers from any breeze.

Above The study in a 1930s *longtang* house, with a Chinese office cabinet of the period and an ancestor scroll painting at right.

DINING ROOMS, KITCHENS AND STUDIES

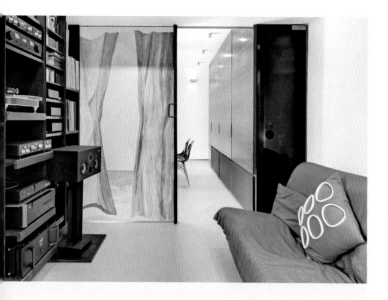

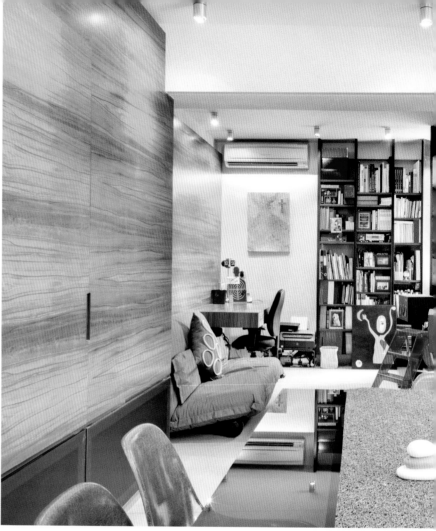

Above In a Hong Kong apartment, the owner's study/music room looks out towards the dining area. The sliding screen has been painted by the owner with a trompe l'oeil effect of shifting gauze curtains against a background that matches the dining room beyond.
Right The view from the dining area, across a table in granite and glass, to the owner's study/music room shown above.

LIBRARIES AND **DENS**

The love of books has led Chinese home owners through the ages to build household libraries for keeping them and enjoying the quiet act of reading. Today, the home library in the middle-class Chinese house is becoming popular as a proprietorial space. Even the sequestered den—a space that is part library, part office and part bolt hole to escape to—has given way to the high-tech and aesthetic demands of the modern home office. On the high-tech side, dens now house entertainment, so design needs to accommodate music and video systems, while computers naturally have their place. On the aesthetic side, libraries and dens are also becoming places for display, utilizing built-in bookcases and shelving for books, mementoes, family photographs and artwork. Unlike the more strictly focused study, there is a demand for comfortably upholstered furniture for sitting and lounging, and a favorite or special chair often appears. Lighting, too, is important for creating atmosphere, and for applying changes when a den is sometimes used as a home entertainment center.

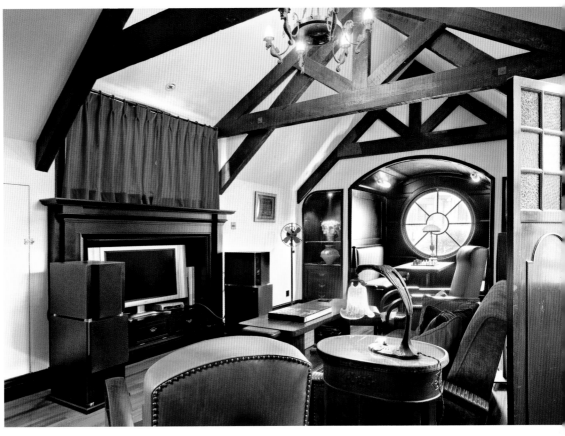

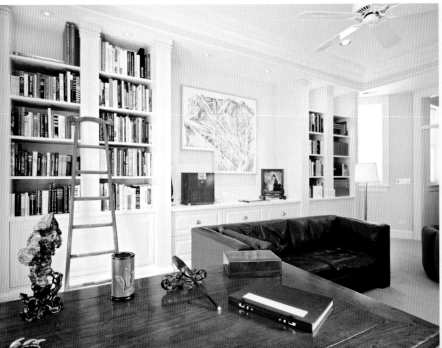

Above The club-like atmosphere of the top floor study, beams exposed, of a restored 1930s British colonial residence in the French Concession district of Shanghai.

Left A seventeenth-century *huanghuali* painting table is the main feature of this library in a modern house in Chicago. On it are a scholar's rock, a carved bamboo brush pot from the eighteenth century made by Feng Ching, a seventeenth-century bronze brush holder and an eighteenth-century *hong mu* calligraphy brush. A traditional Chinese ladder rests against the bookshelves.

DINING ROOMS, KITCHENS AND STUDIES

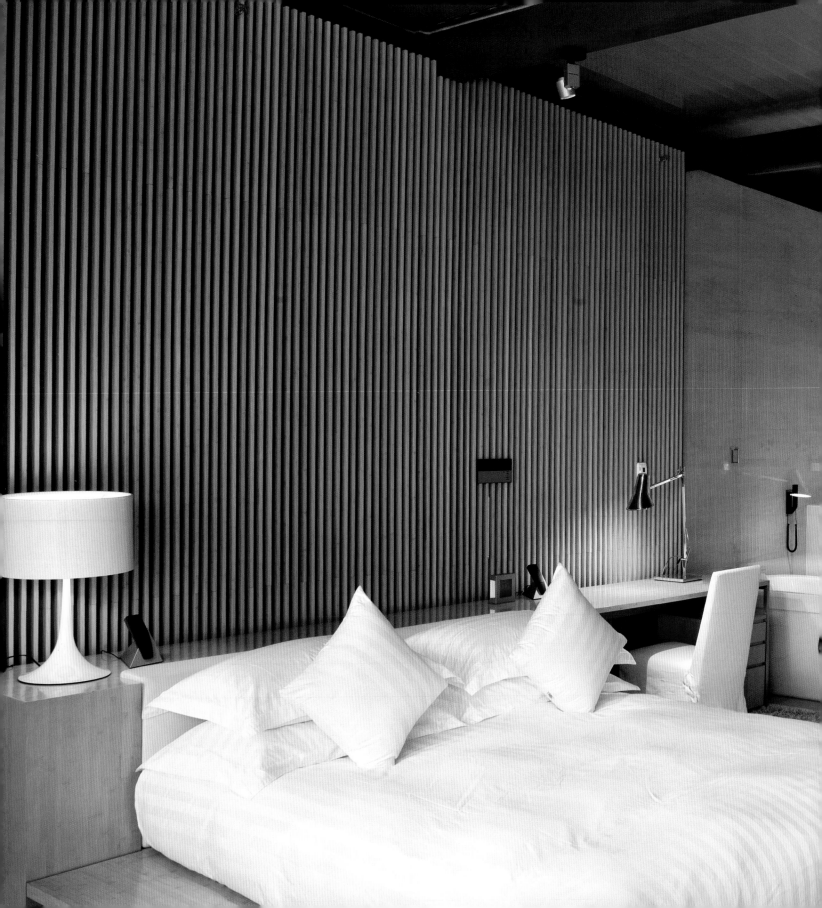

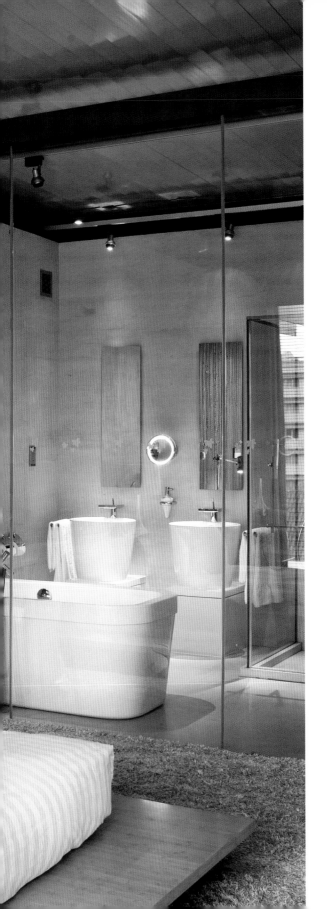

BEDROOMS AND BATHROOMS

This chapter leads us deeper into the Chinese house to enter the bedroom and bathroom—traditionally, of course, the most private of rooms. They are significant spaces, not only from the point of view of functionality—to sleep and to bathe—but in the way they affect emotional well-being. We spend about a third of our lives in privacy here. Other than the intimacy that they represent, the opportunity to suit personality and lifestyle is a principal idea running through them. In this sense, the bedroom is the one room in the house that can express a sense of luxury and elegance among the burgeoning Chinese middle class with the means to indulge. And with bathrooms becoming more and more an extension of the bedroom, they too tend to be designed in the direction of a luxurious and comforting space.

As intensely private spaces, the range of design expression is expectedly large, and the gamut of styles on these pages runs from unashamed luxury to sparse minimalism. We can see here deliberate opulence, with expensive, pampering textures and surfaces, using either modern interpretations of tradition or full restorations of the traditional that make imaginative use of that archetype of Chinese furniture, the canopy bed, that can function as a room within a room. By contrast, there are designs that aim to create comfort and warmth by evoking a more natural aesthetic with Zen-like simplicity. Natural materials, including plainly finished wood and textured stone, offer one route, while another approach bases itself on the calm coolness of white, which allows extra freedom and flexibility for spatial layout. An all-white setting, which typically and naturally extends to the bed linen, draws attention to elements that in different, more complex designs might pass unnoticed. Modernism extends to the careful management of space and to double use. Loft and mezzanine bedrooms have become a popular choice for small city apartments where owners want to get maximum value and comfort within imposed limits.

A penthouse bedroom in Shanghai, designed by Japanese architect Kengo Kuma, who has worked extensively in China. It features a slatted wooden wall and a wooden plinth for the bed, and is separated from the bathroom by a glass wall.

SLEEPING IN
LUXURY

For many people, and increasingly among the new Chinese middle class with the financial means, the bedroom is the one room in the house that can express a sense of luxury. It is, of course, the most private room in most homes and, with increasing size, becomes a place for more than just sleeping. With an open mind to the concept of luxury, many things are possible—exploring the romantic and the elegant without being limited to flower, linen, organza, gold or delicate details. The right combination of color and light, furniture and fittings, including the bed itself, and spatial configuration can create just such a harmony of romanticism and elegance. In these pages, luxury bedroom design comes in the form of 1930s sophistication with Art Deco surroundings, of innovation in the shape and design of the bed (note the cubic simplicity of the contemporary canopy bed below right, minus the canopy), in sliding windows that open the bedroom entirely to an outside garden, courtyard or pool, and in a mixture of traditional Chinese and contemporary accents, such as glamorous red lacquer or luxurious carvings and ornaments. Luxury in the bedroom is very much a matter of personal expression and indulgence.

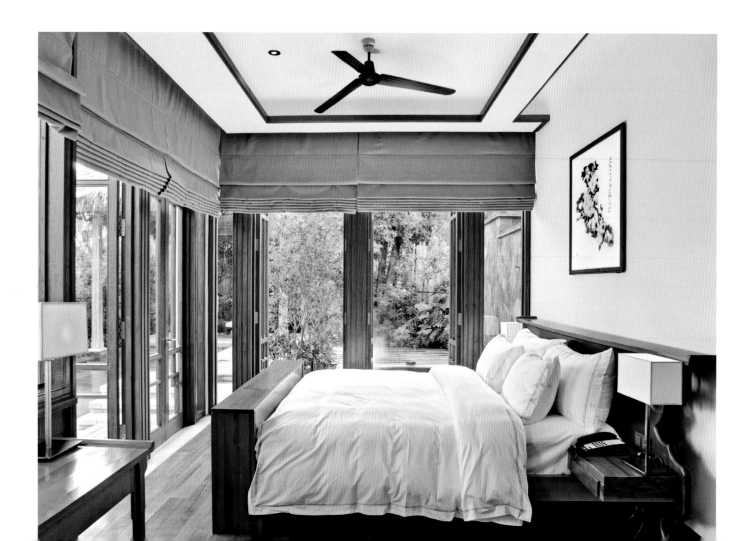

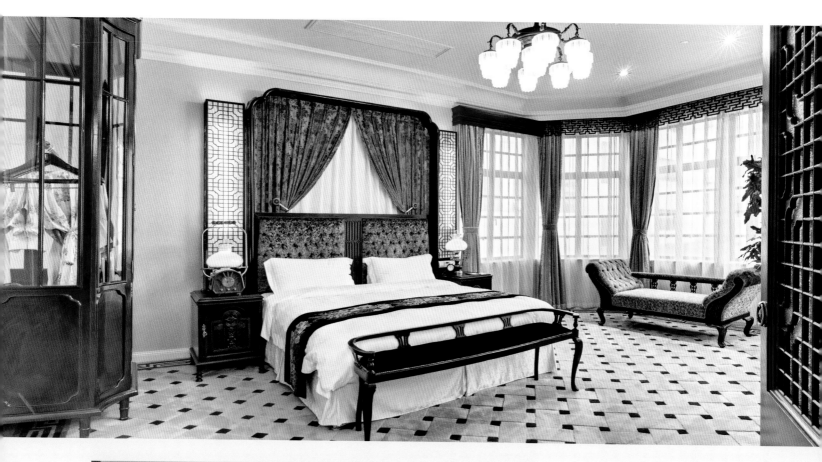

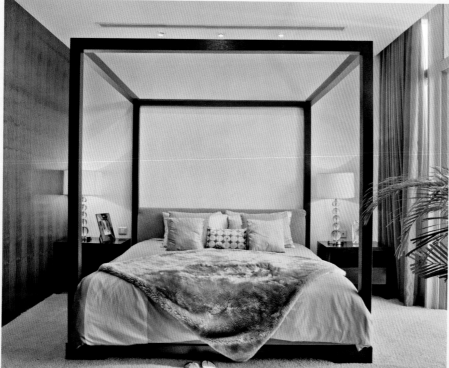

Above The master bedroom of the Pei family mansion seen earlier, with a glass wardrobe at left and a bay window. Backlit vertical panels on either side of the headboard are Shanghai Art Deco designs.
Left The main bedroom of a large contemporary Pudong villa features a modern reinterpretation in stained oak of a traditional Ming-style canopy bed.
Opposite The bedroom of a lakeside villa near Kunming. The French windows open onto a stone-flagged tub, fed from the local hot springs.

Right This bedroom in a restored 1930s Shanghai property retains the original dark wood paneling. The gilt spiral decorations are modern.

Below The bedroom of the penthouse suite featured on page 26, separated from the living room by white chain curtains, contains a round bed in an all-white color scheme.

Opposite above In this bedroom in a converted Beijing *hutong* residence, an exuberant combination of white and red lacquer on modern furniture was inspired by traditional designs.

Opposite below left The bed in this ground floor apartment is dressed with piles of cushions, Chinese woven bamboo summer pillows and bed linen, all in neutral tones. The side table and the dressing table with stool by the window are all contemporary Chinese, in *wenge* wood.

Opposite below right Soft luxury in this modern Hong Kong apartment bedroom is helped by the gentle color scheme of green silk walls, gray and cream Italian bed linen, neutral carpet and raw silk drapes.

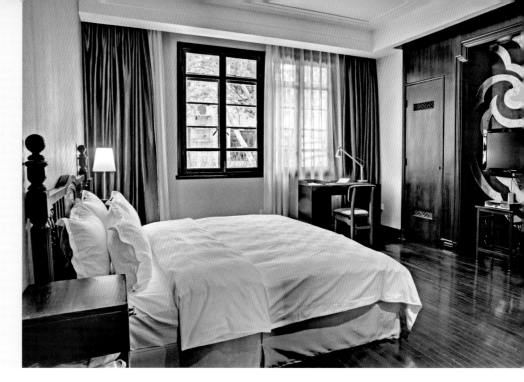

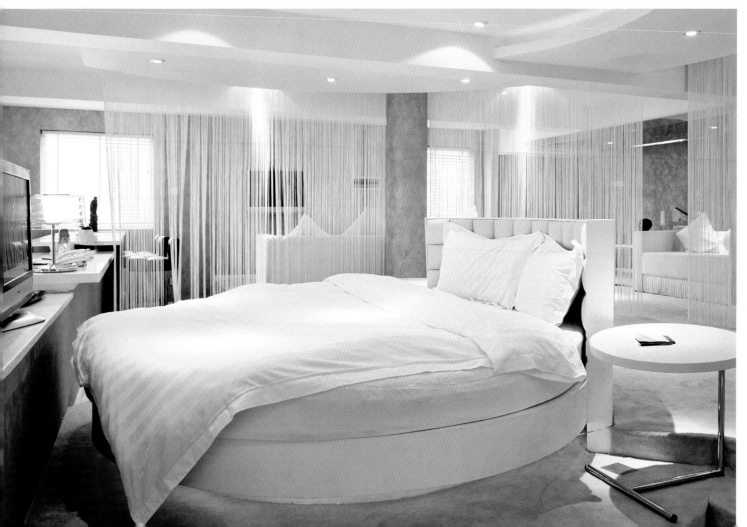

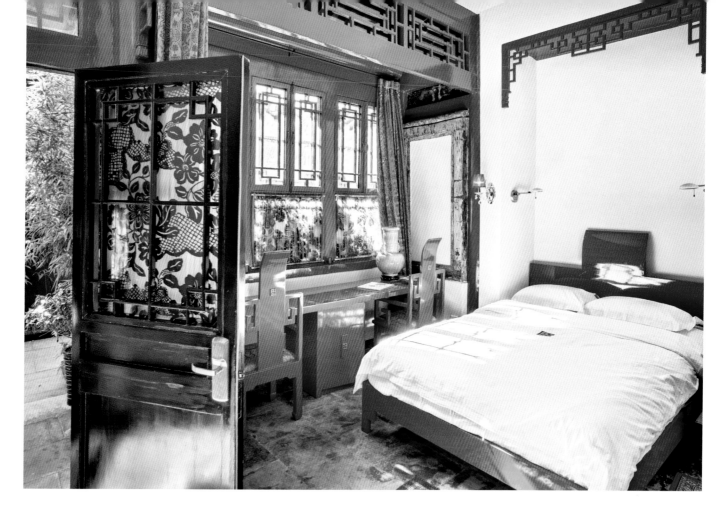

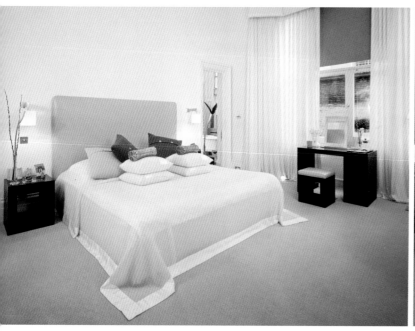

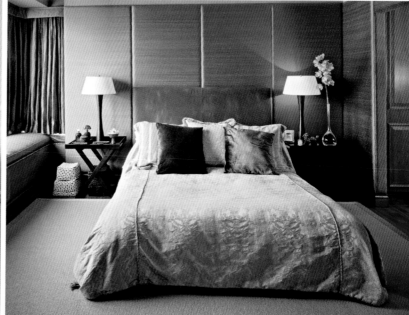

BEDROOMS AND BATHROOMS

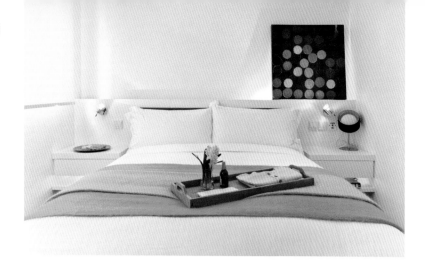

COOL **WHITE**

While many bedrooms that aim to be spectacular are compromised by garishness and excess in elaborate and over-carved beds and furniture, and by strong colors that distract rather than enhance, the modernist approach in the Chinese bedroom can be calmer, more reliable and more pleasing to the eye. Whiteness, as exploited in the examples here, allows extra freedom and flexibility for spatial layout but demands care and is not so simple a theme to manage, despite appearances. An all-white setting, which typically and naturally extends to the bed linen, draws attention to elements that in different, more complex designs might pass unnoticed. Single non-white features become strong accents and can be both powerful and complementary when chosen well, such as the purple bed throw, the pair of red fabric lanterns and the carved wooden pediment from a temple. Furniture, too, and its placement, make strategic complements that can help the harmony, as in the use of an antique Ming armchair below and at right. Whiteness, naturally, signifies purity and this, in turn, introduces a philosophical element. In essence, a well-designed white-themed bedroom is a blend of modern style, philosophy and harmony.

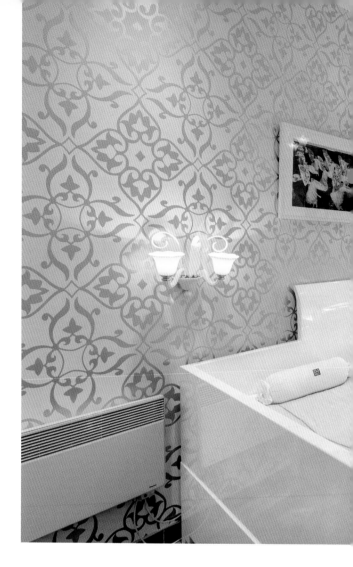

Top A simple minimalist bedroom in a small Hong Kong studio. The translucent white blind and concealed lighting create a calming atmosphere.
Right The bed here is dressed in white linen that merges with the all-white decor. A sixteenth-century Ming copper hand warmer and an eighteenth-century Ming elm wood armchair provide Chinese accents.
Center right Translucent white curtains can be drawn completely around this Beijing bedroom to simplify the space, but are here parted to reveal a triangular wooden temple pediment.

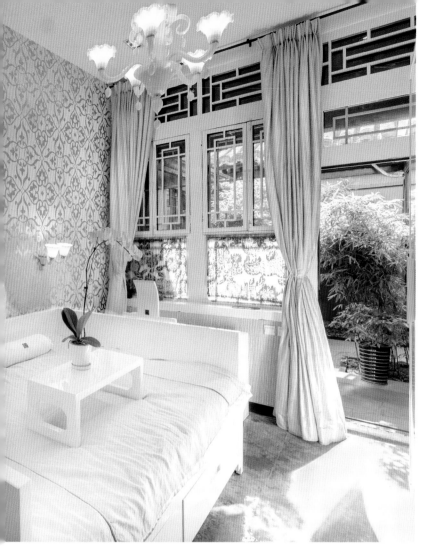

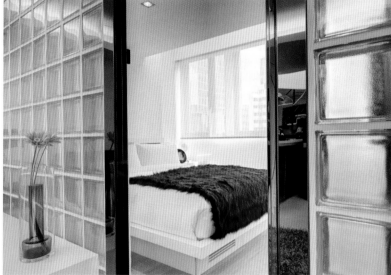

Left An all-white bedroom with silver-on-white floral wallpaper. The contemporary white-lacquered bed is inspired by a *luoyang* daybed.
Below A purple throw provides a strong splash of color to this all-white Hong Kong bedroom, its inner wall composed of glass bricks. A simple glass vase with gerberas stands by the door.
Bottom In a tiny Hong Kong apartment, designer Johnny Li introduces red-fringed acetate lampshades for color contrast in a white-and-oatmeal styled bedroom.

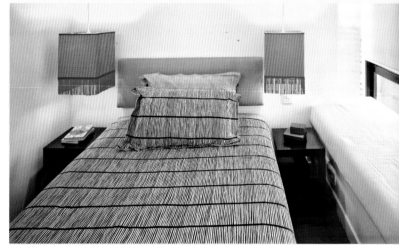

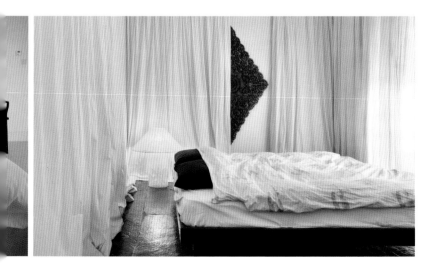

BEDROOMS AND BATHROOMS

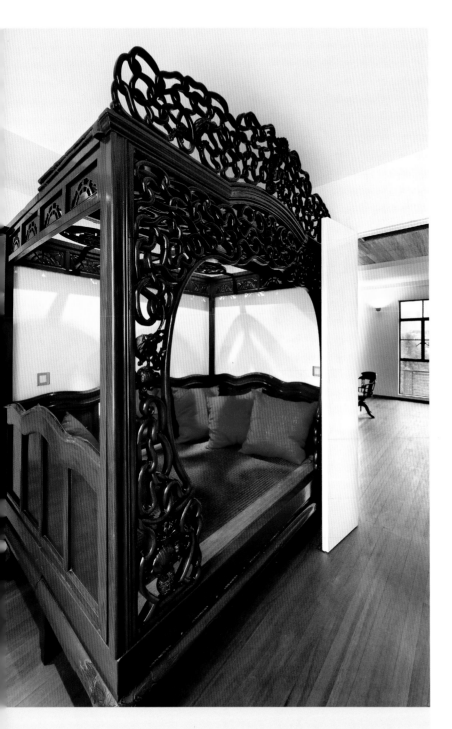

CHINESE
CANOPY BEDS

A striking piece of furniture, the canopy bed has a long history and still persists today in modern Chinese bedrooms. With high posts at the four corners, canopy beds lend themselves admirably to use as the focal point of the bedroom. The structure is traditionally intended to hang draperies from for a dramatic effect and to change the mood of the room. During the Ming and Qing dynasties, the Chinese developed a particular style of canopy bed. Usually smaller and more delicate than its European counterpart, the four-poster, the Chinese version typically also has two extra posts on one side, and is often decorated with ornate wooden carvings that feature lattice designs and dragons.

Although classic in style, the canopy bed can be modified to suit modern tastes. Its substantial size and volume sets up a particular spatial relationship with the room, and its placement depends on the configurations of the space. Nevertheless, without the accepted strictures that once applied, all kinds of things are possible, as in the strong statement in the small studio flat at left, where the canopy bed fills the room and is a focal point for the entire apartment. Above all, such beds are three-dimensional sculptures that can be admired for their visual harmonic beauty.

Opposite above left A Ming dynasty canopy bed with decorative latticework is here used as both retreat and conversation piece in the reception area of a house.
Opposite above right A canopy bed makes an ideal bed-cum-play space for a child, with its room-like coziness and structure to hang and lean things on.
Right An ornate Qing canopy bed, its openwork decoration partly gilded, in a Peranakan (Straits Chinese) house in Melaka, Malaysia.
Far right The substantial structure of this antique Chinese canopy bed contrasts with a geometrically simple low table topped with sandblasted green glass.

Above In an otherwise open-plan conversion of a small apartment in a 1930s Shanghai block, the tiny bedroom was designed around the owners' antique Chinese canopy bed.

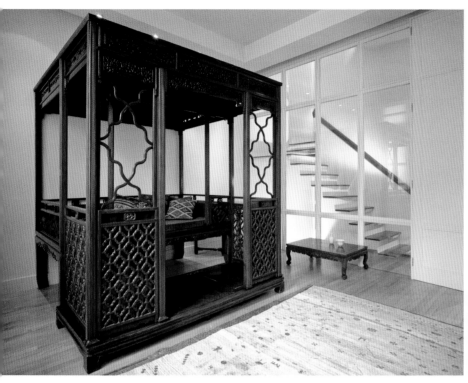

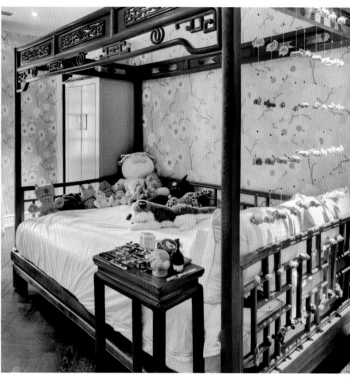

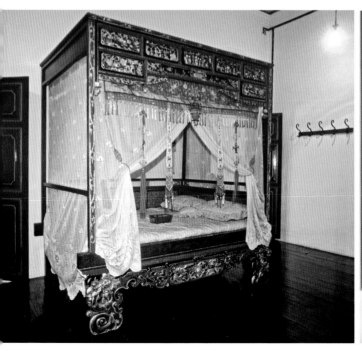

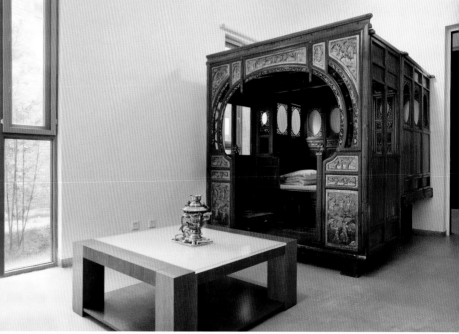

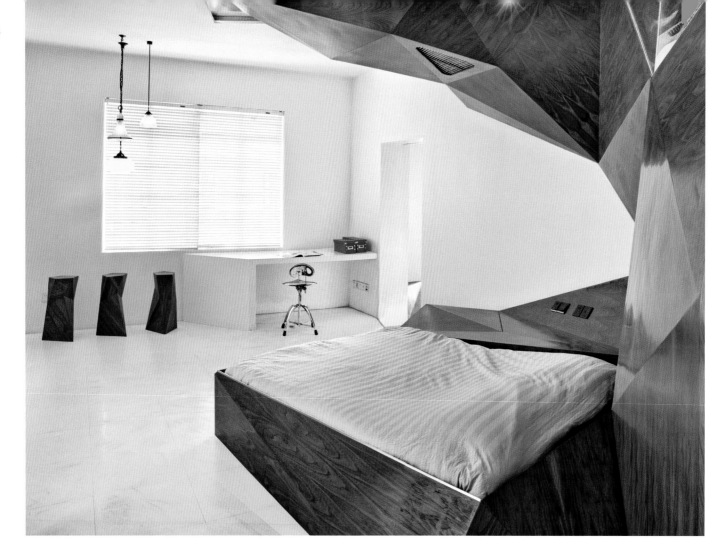

MODERN
BEDROOMS

Modern means not just contemporary, but suggests an inclination towards modernism, an originally European movement, but one that is compatible with the clean lines and functional designs of Ming furniture. It also harmonizes with many Zen tenets that are becoming increasingly popular in China. Overall, modern is probably the most conspicuous trend today in interior design. Key ingredients in the creation of a Zen-like simplicity are light, neutral tones, such as pure white or off-white or even a pale, understated gray, and with the same intention but invoking a warmer and more natural aesthetic, pale wood and earth tones. Take, for example, a warm and clean-lined Zen-style platform bed as at right and on pages 74–5, where the themes of nature and modernity are extended to the continuous veneer of vertical wooden slats. With all of this, minimalism is never far away, and bedrooms in a modern style typically reduce furniture and fittings. The most radical example of this, above, from vanguard designers in Shanghai, experiments with an innovative and strongly geometrical configuration of bed, furniture and utilities, designed as a three-dimensional model and embedded into the structure of the apartment. Integration like this, and as in the bedrooms on the following two pages, is minimalist in concept, and is well-suited for small urban spaces.

Left The bedroom of the innovatively converted lane house on page 41 contains sculptural cabinets that incorporate the bed frame and full-size, built-in wardrobes. Facing are a table and stools designed in the same angular style.

Right A smoked-glass wall separates the living area from the bedroom in this small studio apartment. The central section of the glass wall revolves on a steel pillar, to which is mounted the television screen, so that it can be viewed from either side.

Below Here, minimal simplicity is the designer's solution to the restricted space. A backlit panel over the headboard can be programmed to different colors.

Bottom left The same bedroom as at right, enlivened by a combination of white, wood paneling, smoked glass and orange transparent Perspex/Plexiglas.

Bottom right The bed in this Shanghai penthouse suite rests on a cantilevered wooden plinth. Electronically controlled louvered panels above control light through the glass ceiling.

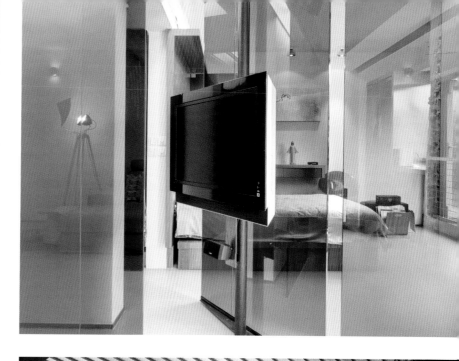

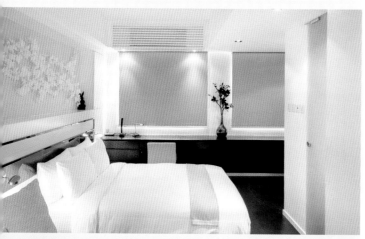

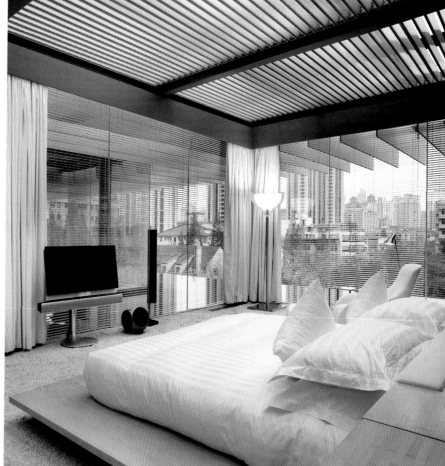

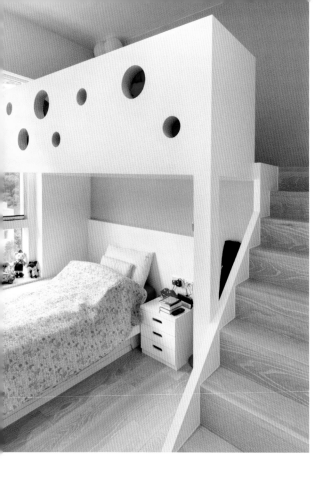

SPACE-SAVING **SLEEPING**

Modernism extends to the careful management of space and to double use. Loft and mezzanine bedrooms have become a popular choice for small city apartments, where owners want to get maximum value and comfort within imposed limits. Techniques include making use of part of the upper half of the room's volume, in fitting beds into otherwise wasted spaces such as alcoves and under-roof areas. With a loft bed, the mattress is raised on a platform that is several feet off the ground, which enables the area beneath to become multifunctional, so that where there once would have been only a bed, there can now be a built-in desk, computer station, seating or storage space. For young singles, in particular, this extra study, relaxation or storage space has obvious value. Color and lighting can support this arrangement by helping to maximize space visually and avoid any sense of crowding or overfilling, and all the examples here demonstrate this, with light and bright color schemes and the use of concealed lighting to help 'lift' sections of the structure. In the mezzanine design at right, for example, the lighting above helps to open up the higher part of the space and produce a sense of airiness.

Above A child's bedroom designed by Anderson Lee features a partly enclosed mezzanine play area cut with holes for peeping through.
Right A second mezzanine bedroom in the Zhong Song apartment saves space by extending the sleeping area under the eaves, with a new skylight added.
Far right A wood veneered U-shaped bed frame and concealed lighting beneath make the bed in this tiny Hong Kong apartment seem lighter and less space-filling.
Opposite above left and right By extending upwards into the gable area of this top floor Beijing apartment, designer and owner Zhong Song has created a mezzanine sleeping area. The steel frame of the black wardrobe provides structural support.

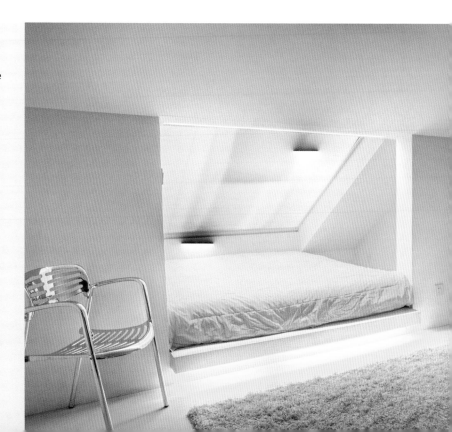

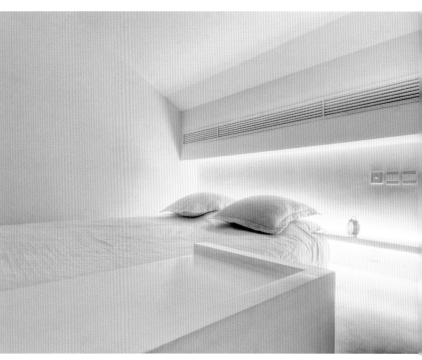

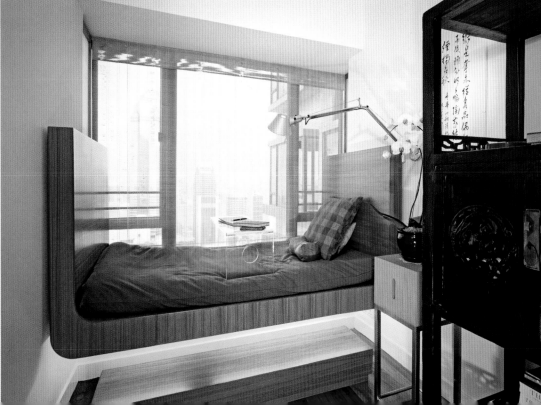

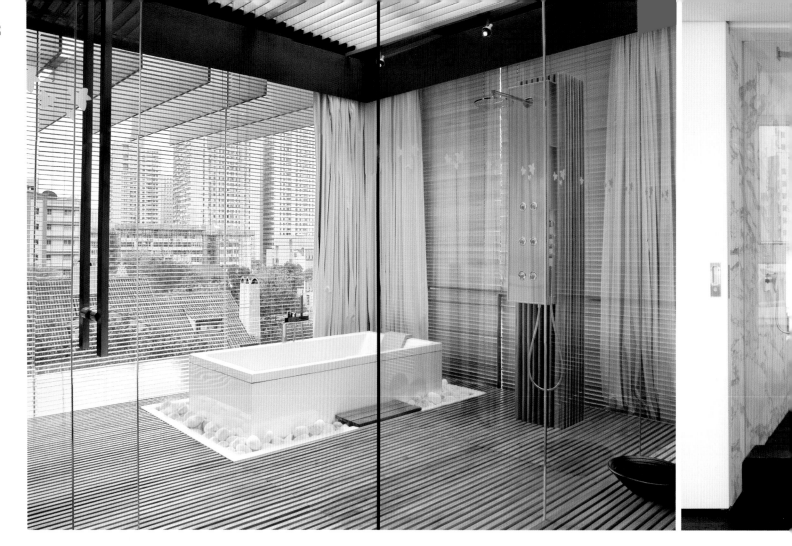

TIMBER AND STONE **BATHROOMS**

Designed for spatial effect with a natural and modern touch, the bathrooms of an increasing number of Chinese houses are following the contemporary trend towards the natural by using timber and stone. Both of these materials, which may be combined or used exclusively, can achieve different ambiences—either strong, rich and solid with dark tones, or light and fresh with light-colored timbers and stone varieties. Some bathrooms obtain a smooth, sensual finish in the familiar travertine stone and black marble, while with timber panels in Chinese elm, the style tends towards a dignified warmth. The wall in a bathroom has a major influence, and is treated in several ways here, from the more expected bright and patterned mosaic tiles to individual and artistic expressions, such as the iridescent jagged swathe of blue tiles making a startling contrast with a gray cement render. For those spacious properties that allow it, walls of glass bring in an uninterrupted flood of daylight, and in the case of the spectacular Shanghai penthouse above, give the owner fabulous views of the outside. When wooden panels and louvers are incorporated into the design, a Zen-like feeling is added to the more sensual comfort of a window-side bathtub.

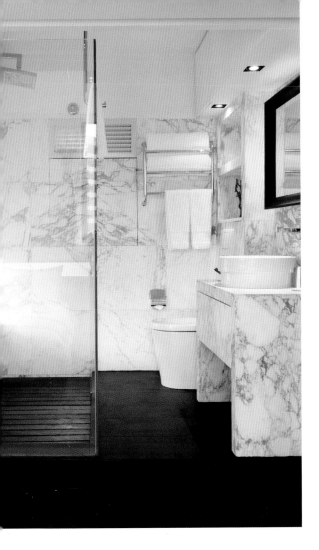

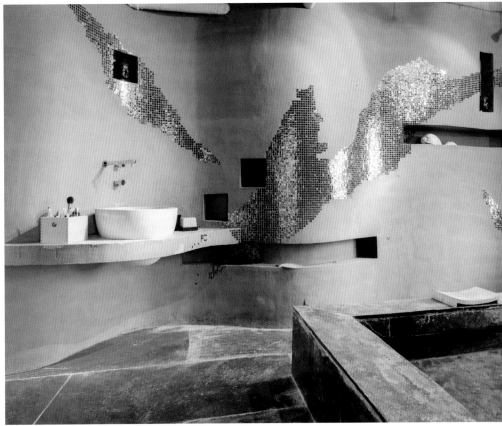

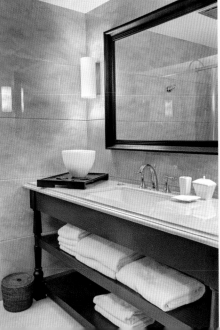

Opposite above The bathroom of a Shanghai penthouse. The slatted wooden floor is mirrored in the electrically operated louvered ceiling. Surrounding the bath is a trough with pebbles, underlit with a changing color cycle.

Above left A Hong Kong bathroom by designer Miho Hirabayashi in white and gray marble with glass shower walls. The sliding white door fits flush with the wall to completely conceal the bathroom from the bedroom.

Above Stone and render over curved plasterboard transform the bathroom of a Beijing city apartment into a surprisingly rustic and natural space. Both floor and bath are in stone, while iridescent mosaic shapes break the smoothness of the rendered wall.

Left A classic Art Deco guest washroom in a substantial 1930s house in Shanghai's French Concession.

Far left Designed by Yu Yongzhong, a fancifully delicate and tall 'chair' is a bathroom stand for toiletries, seemingly doubled by the full-wall mirror.

BEDROOMS AND BATHROOMS

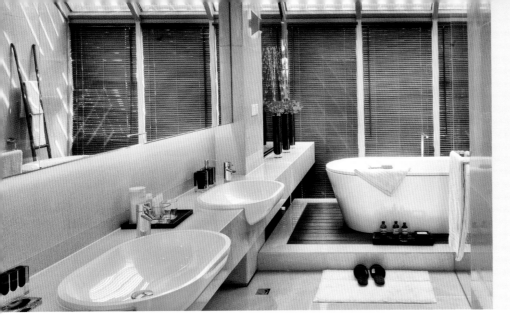

Left Light floods the end of this spacious bathroom through a louvered glass roof. Wooden slats line the bathtub area, while marble is used in other parts of the bathroom.

Below The skewed angles of this bathroom inspired the designers to create interlocking patterns of two contrasting surface finishes: mosaic tiles and polished concrete. This extends to the ceiling.

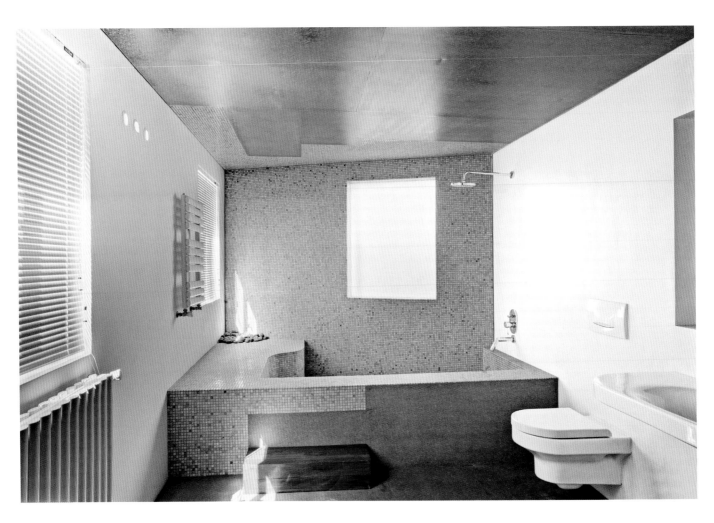

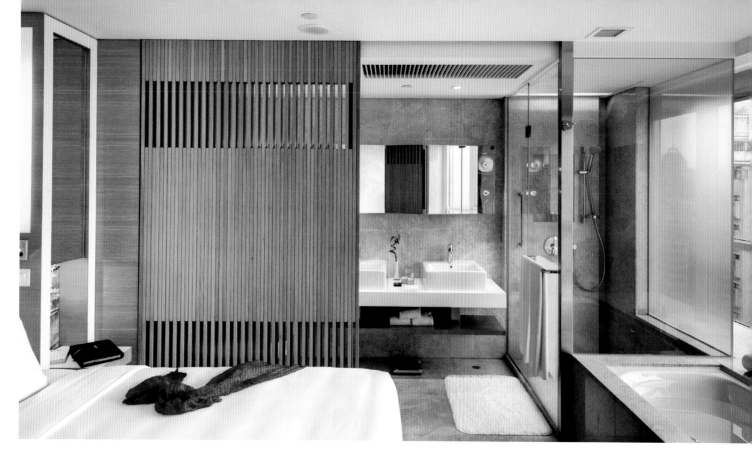

Above A studio apartment in Hong Kong, looking through to the bathroom from the bedroom.
Left A view from a corridor to the toilet in a Hong Kong studio apartment. A heavy sliding door, its recessed pull visible at left, seals this area off from the rest of the apartment.

BATHROOMS WITH **COLOR**

Another popular trend in modern Chinese bathrooms is to use color for a dynamic effect. An innovative combination of colors in walls, floors and glass becomes the keynote and serves to enliven the usually small space. Bathroom fittings themselves are usually white and chrome, but bright color can be used to offset this essentially minimalist finish and illuminate the vibration of space. Splashes of color can be applied in a variety of ways, as we see here, from a brilliant red-painted wall immediately at right, to mosaic tiles, to concealed lighting that lifts a small colored area into a much brighter state. Perhaps most striking of all is the use of backlit glass windows and walls. The vertical strips of glass in alternating yellows, reds and greens below right is pure Shanghai Art Deco, while the floor-to-ceiling bright red peonies on the glass wall below is a nostalgic call for historical memories. A colorful bathroom in a Chinese house is out of tradition and an entirely modern phenomenon, but as a small space that is visited for relatively short times it offers the opportunity for experiment. It is a place in which the owner or designer can assert personality and make a creative statement.

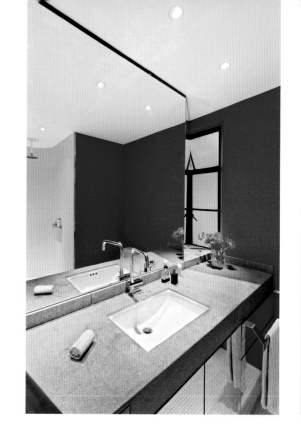

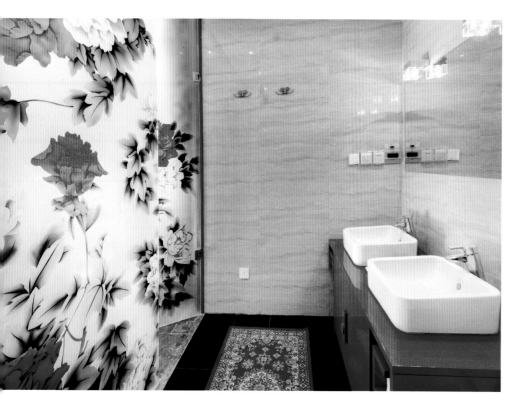

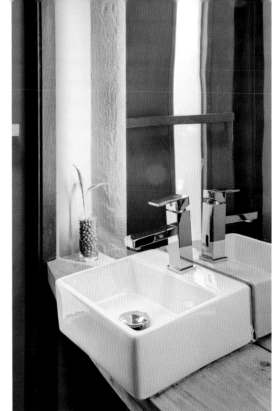

Above, from left to right A simple and striking arrangement of red wall, granite counter and large mirror enlivens this small shower cubicle and wash-room. A bathroom with mosaic tiles and a wooden washstand constructed with an angular version of a scroll end. This idiosyncratic bathroom arrangement in a modern Beijing apartment occupies a free-standing unit in the center of the open-plan space. Concealed lighting behind the mirror lifts the mood of this brightly colored small washroom off the courtyard garden in a Shanghai house.

Left The original Art Deco glass paneling in a vibrant geometrical design on a toilet door in a restored French Concession house.
Far left A sandblasted glass wall carries a design of peonies in the bathroom of a converted *hutong* in Beijing.
Right In this conversion of a Shanghai lane house in a terrace, the designer made use of the typically narrow light wells between houses to bring light to one bathroom. The floor tiles are Venetian glass.

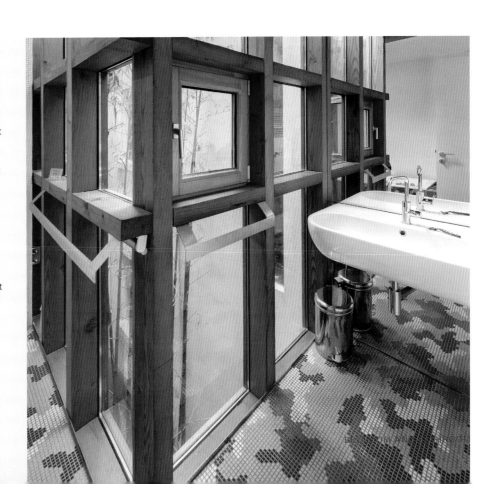

Right A miniature display stand on a bathroom ledge. Chinese miniature furniture is a popular collectible.
Below A bathroom in Pudong features a glass bowl washbasin and glass vases with agapanthus against a wall mirror.

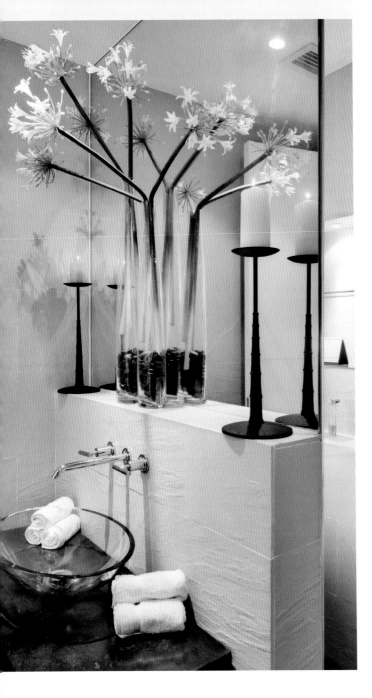

CONTEMPORARY
BATHROOMS

The bathroom designs here employ a variety of methods to achieve a contemporary effect, from overall concept in some cases to small but telling details in others. The examples here have in common a choice of minimal furnishing, a generally white and pure backdrop, as well as carefully planned lighting, all of which combine to give a more spacious impression visually and to make the space more enjoyable. Harmony and simplicity rule, and in this way contemporary bathroom interiors are designed to bring peace, balance and serenity to the space. In what are relatively uncluttered spaces, a careful choice of decorative elements is important. Flowers and candles do this in the bathroom at left, an exquisite antique miniature furniture piece is the choice above, while items that reference Chinese traditions are found at right, including a porcelain drum stool but with a chrome metallic finish, and towel racks in bamboo or wood that recall the tapering shape of traditional Chinese ladders. In these styles of contemporary bathroom, lighting is an essential component of the space. Good lighting design contributes two things in a bathroom: one is to add to the ambience and decor of the room, and the second, not quite so obvious, is to attractively light the figure of whoever is using the bathroom—mirrors are, of course, mandatory in bathrooms, and the view into them needs to be good. Concealed lighting and artfully positioned downlights both make useful contributions.

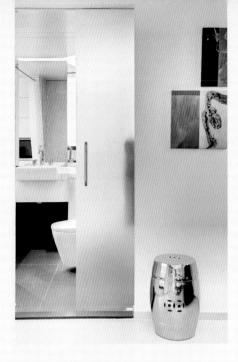

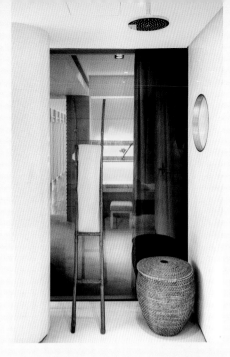

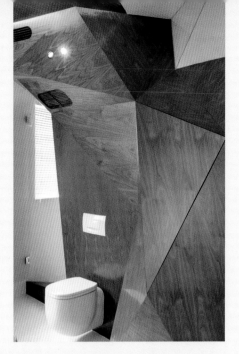

A silver-enameled porcelain drum stool adds a hint of tradition to this contemporary bathroom, with its recessed sliding sandblasted glass door.

A glass wall separates this bathroom from its bedroom. The bamboo towel rack references traditional Chinese ladders.

The toilet of the apartment featured on page 84 utilizes the same multifaceted arrangement of triangular-doored cabinets for storage.

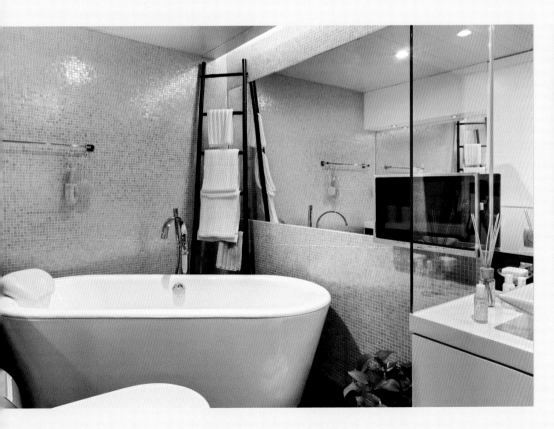

Above A square steel cap on this washbasin tap serves as a temporary place for toiletry items.
Left A bathroom and toilet in a Hong Kong apartment, tiled with mosaics and with a freestanding tub. The towel rack hints at a traditional Chinese ladder. The mirrored wall helps to expand the small space.

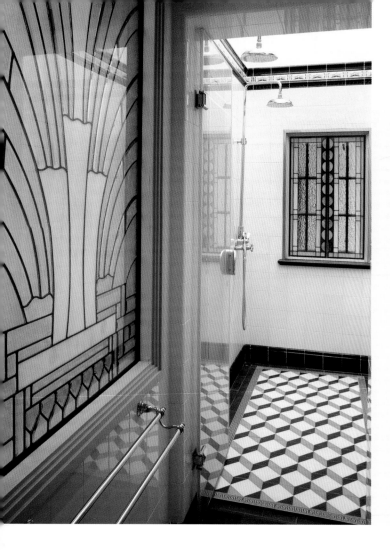

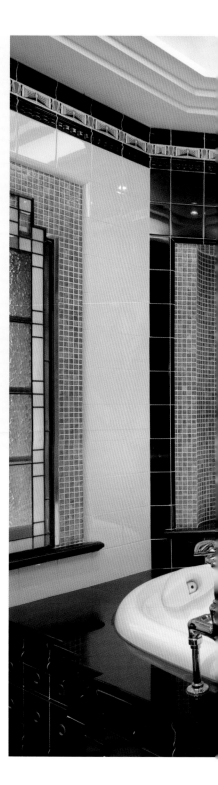

Left The shower room in a carefully restored British colonial house in Shanghai features original Art Deco stained glass on the door and window, and tiles by British company Original Style, handmade to the original designs.
Right In the main bathroom of the same 1930s house, a reproduction of a painting by the well-known Art Deco artist Lolita Lempicka is the centerpiece.

Opposite above A 1920s marble-topped wooden washstand converted for modern use, with a contemporary drained washbasin.
Opposite below A restored antique hip bath in an old Shanghai house.

RETRO STYLE **BATHROOMS**

The retro style may exploit nostalgia, but in a contemporary interpretation, it is never overly serious. The touch stays light and with even a hint of irony. It is the largely Art Deco design of the 1930s that is the most reproduced and re-created. It was developed and interpreted in Shanghai, a city that owes all to the foreign concessions, where China and the West competed and integrated at the same time, but is recognized universally. This style is now becoming almost as popular as when it first evolved. It began in 1920s Paris, though the name Art Deco became common only in the 1960s when it was used to refer to the defining 1925 exhibition on Arts Décoratifs. As an eclectic form of modernism, Art Deco is typified by linear symmetry and, as seen in the exquisitely restored shower room above, crystalline and faceted motifs. Pastel shades, again obvious above, and concealed lighting, exemplified by the geometrically ceilinged bathroom at right, are also essential features in interior design. Above all, Art Deco was conceived as highly decorative and basically ornamental. With the rise in Art Deco's popularity, bath and washbasin manufacturers are beginning to reproduce these designs.

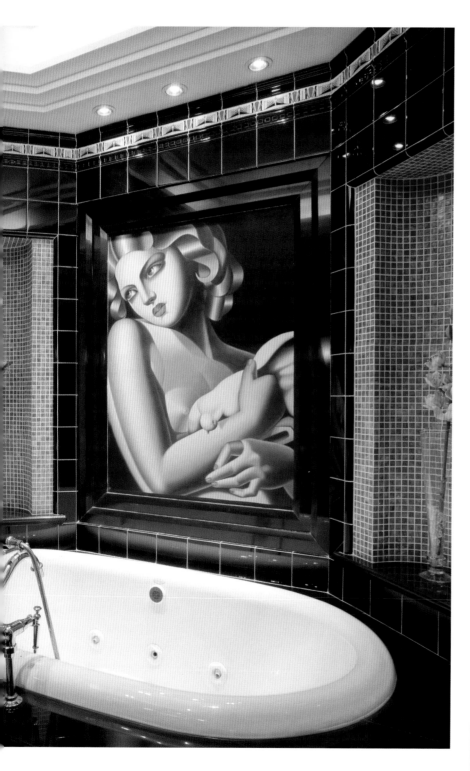

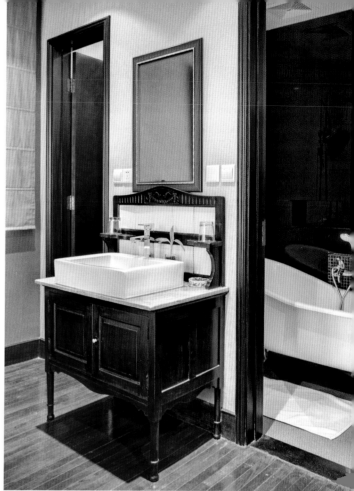

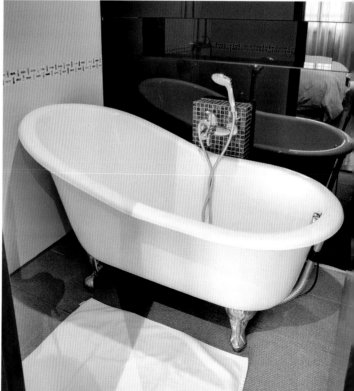

Right In the constricted space available, this small bathroom achieves a sense of space and style by the use of curved sheets of stainless steel on the wall and on the side panel of the bathtub.
Far right In this design by Anderson Lee, a glass wall encloses the bathtub. The adjacent vertical shelved display niche is lit with a recessed downlight.
Below In a bathroom designed by collector Elisabeth de Brabant, the washbasin bench is enhanced with a silvered woven bamboo basket.

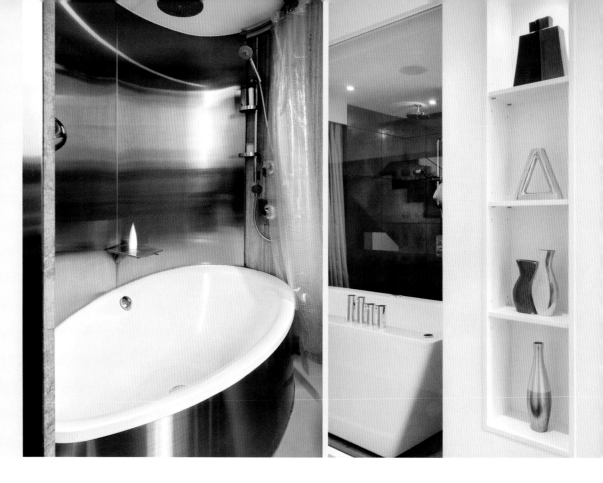

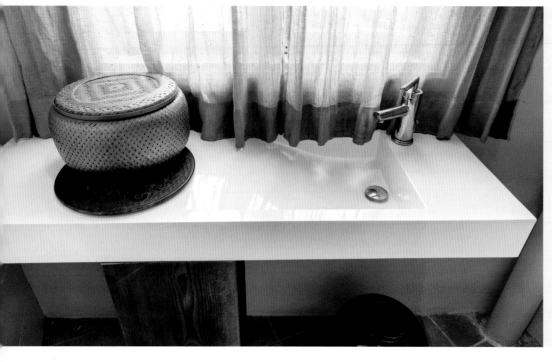

Opposite above A make-up mirror with lighting set into its frame is hung on a glass wall above a freestanding washbasin.
Right A strong sense of luxury is created in this large bathroom dominated by a round bathtub, by the mosaic tiles on the floor and the sweeping circular surround to the tub, all reflected in angled mirror sections covering the curved wall.

BATHING IN **LUXURY**

With bathrooms becoming more and more an extension of the bedroom—one-for-one and *en suite*—it is little surprise that when the tendency is towards a luxurious and elegantly comforting bedroom, as we saw on pages 76–9, the bathroom follows suit. Bathing can be an excuse for luxuriating in elegant surroundings, and this pervades every material and detail, from timber panels in Chinese elm, exquisite mosaic tiles, elaborately shaped bathtubs, in one case at far left an innovative use of brushed and curved metal, and an expanse of travertine stone and Chinese marble. The allusions are to both comfort and visual elegance. At the same time, the use of 'light' materials, such as glass and translucent panels for walls and ceilings, helps to create a calming serenity, visual neutrality and, in the case of mirrors such as those below, a gentle animation created by the effects of reflection. Mirrors can even enhance the sense of bathroom luxury by interacting with carefully designed lighting.

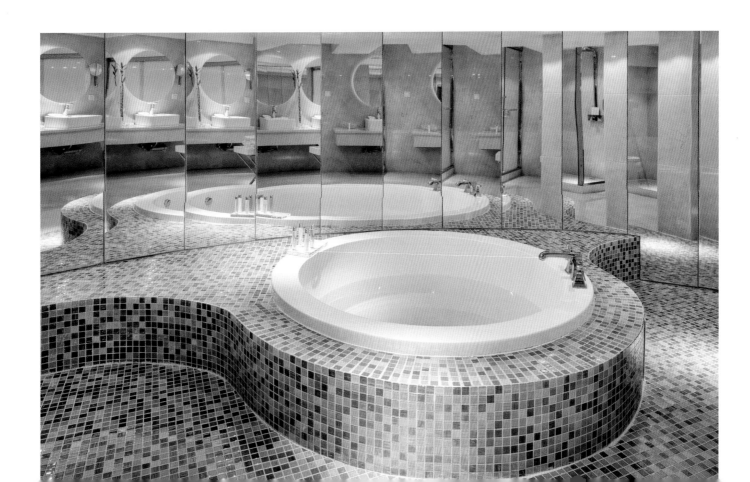

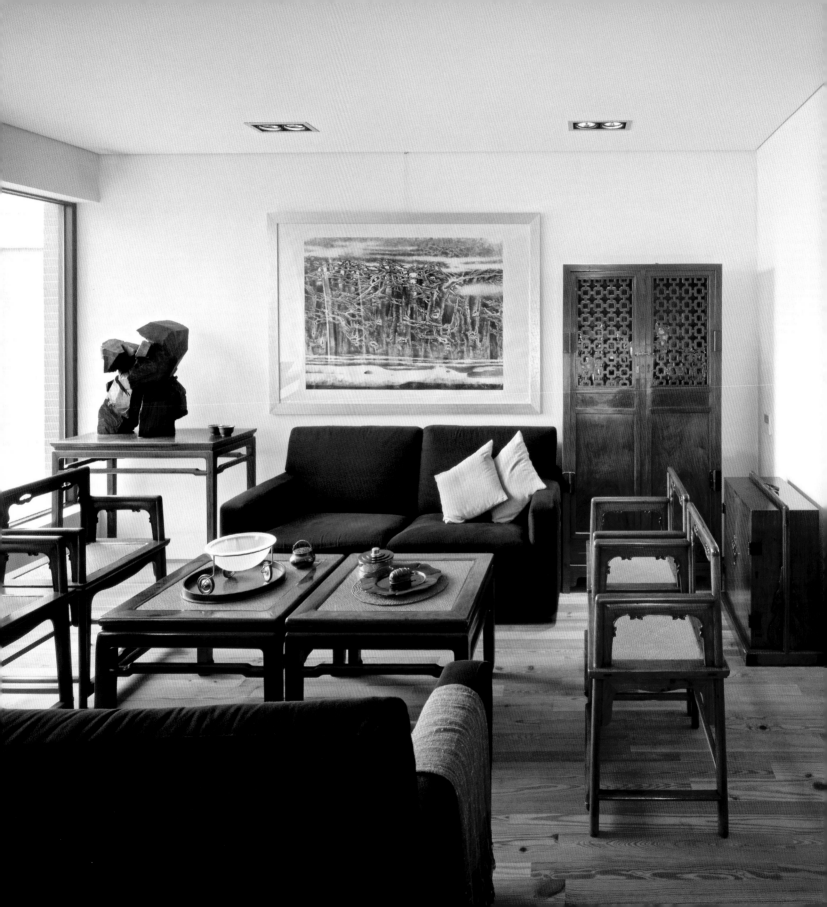

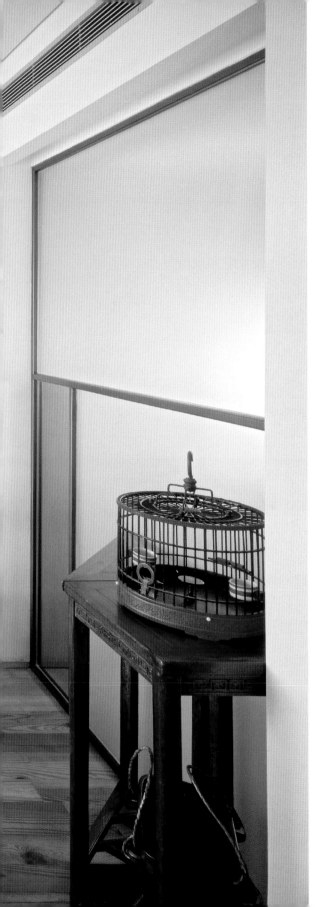

FURNISHINGS AND ACCENTS

As in any contemporary interior design, furnishings and details in China vary hugely and imaginatively. Retail business and fashion demand it. Yet, in the Chinese world of interiors, the influence of traditional furniture makes itself felt in a way that does not happen in the West. Two things have brought this about: first, the sheer length of historical development of chairs, tables and display stands, among others, and second, the refinement and simplification of line that reached its peak in the Ming dynasty and which suits modern taste and thought so well. This expression takes two forms: that of antiques or fine modern reproductions used in a modern context, and that of inspiration and a jumping-off point for contemporary designers who want to refer to tradition rather than simply import it.

The strong aesthetic appeal of Chinese traditional furniture is due to its simple lines as well as its use of natural materials, such as the finest hardwoods. Nothing is hidden, and the wood is polished, stained or lacquered to evoke its natural earthiness and grainy patterns. As we can see in this chapter, traditional furniture 'goes' with so many varied themes. In its contribution as an influence on contemporary furniture design, it plays a more intellectual role by giving an 'idea core' around which young designers can work.

Whether used as they are, or more obliquely as inspiration for designers, the entire range of Chinese furnishing and accessory forms, from chairs to screens to objects, helps to satisfy a growing demand for meaning and history among an increasingly aesthetically conscious Chinese market. 'Ikea-ization' is a global trend that, unfortunately, tends to level the field of design, and is now being resisted by a new generation of informed home owners as well as designers in China, who prefer a sense of continuity with China's rich design history.

Fine Ming furniture comprising two pairs of low-backed Rose chairs and a pair of stools assembled as a coffee table, all in *huanghuali* wood, form the centerpiece of this restrained, elegant Hong Kong living room, along with contemporary sofas.

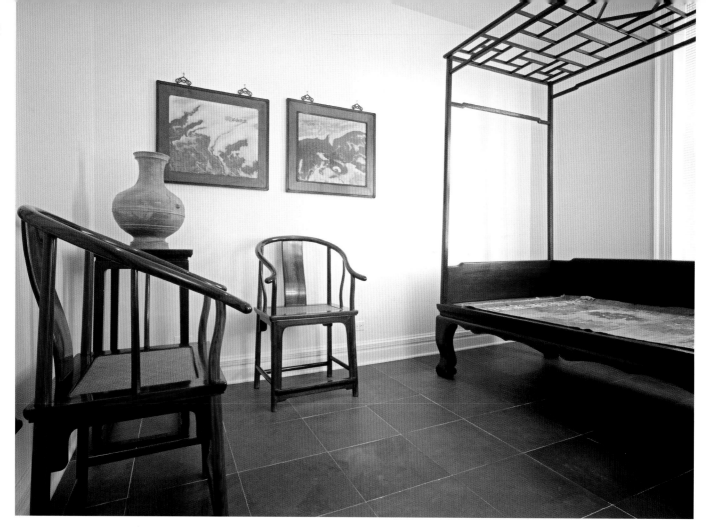

CLASSIC **CHINESE FURNITURE**

Classic Chinese furniture embraces artistry and craftsmanship, whether it is the graceful curves of a horseshoe-back chair or the subtle beauty of an antique cabinet or chest. The ideal has always been to display simple, elegant lines, and especially graceful curves, and to render these with superb craftsmanship. The quality and accuracy of joinery was so precise that nails and glue were unnecessary. When metalwork was added, such as handles, hinges and lock plates, it was designed to complement the graceful lines of each piece. Their timeless simplicity and perfect proportion mean that they are still graceful and appropriate even in the most modern Chinese house, suggesting that the elite scholars and officials of the time preferred a more refined and restrained finish. The range of finishes that were used for furniture of the Ming period included heavy carved lacquer, occasionally inlaid with mother-of-pearl or agate; plain red or black lacquer; and a more natural finish, allowing the grain to stand out and the beauty of the wood to be the main focus of the piece. The Ming aesthetic continues to influence interior design to this day in China. With its philosophy of functional design and simple materials, it remains a cornerstone of contemporary decoration. And with only a small table and a couch bed installed, people can recognize a room's charm. By this means, quality takes precedence over quantity.

Left A guest bedroom is furnished with an eighteenth-century four-poster bed in chicken wing wood and a pair of horseshoe chairs flanking a black lacquer elm wood incense stand holding a Han dynasty pot. Above are two Qing marble panels in *hong mu* frames.

Below The view from inside a finely decorated Ming canopy bed with latticework panels, towards a brass-fitted double cabinet.

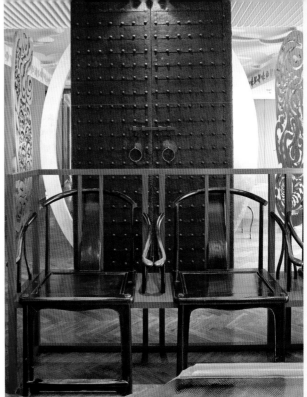

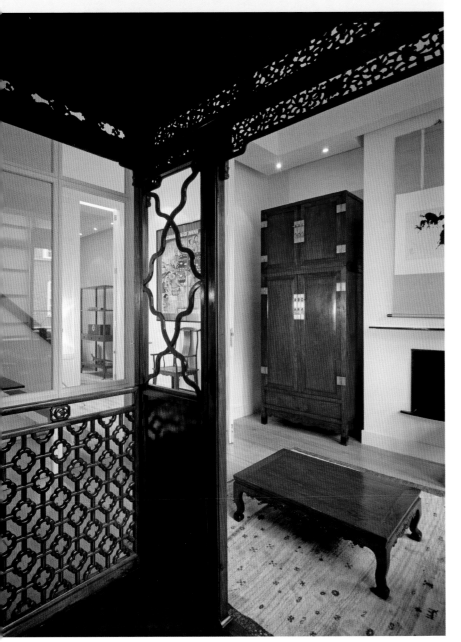

Above In the Pearl Lam apartment in Shanghai, antique doors act as a dividing wall. The seating—two Ming chairs intersecting with a red-lacquered modern frame—is by artist Shao Fan.

Below Ming chairs and a *kang* table in *huanghuali* wood furnish a bedroom.

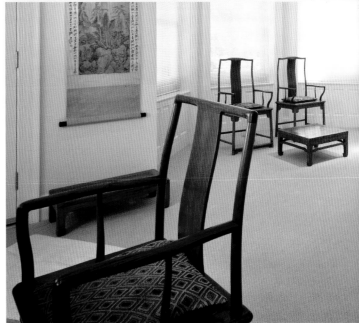

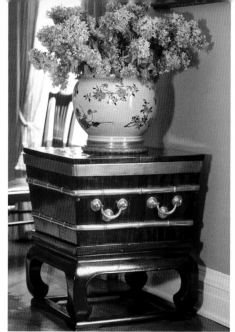

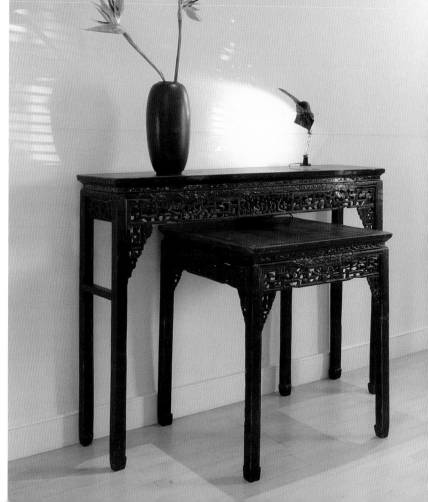

Opposite above left A brass-handled chest with an inverted taper and recurved legs.
Opposite above center A Qing side table with a raised shelf with everted flanges.
Opposite above right A chest with brass fittings in the Ellsworth apartment.
Opposite below left A *zitan* wood hat stand from 1920s Shanghai. The birdcage is also in *zitan*.
Opposite below right A pair of nested Qing altar tables.

Above A nineteenth-century Chinese medicine chest with twenty-five individual drawers.
Above right A seventeenth-century *huanghuali* tapered wood-hinged cabinet.
Right The end of a bronze sofa with openwork carving following a traditional Chinese cloud motif, and hand-embroidered silk upholstery.

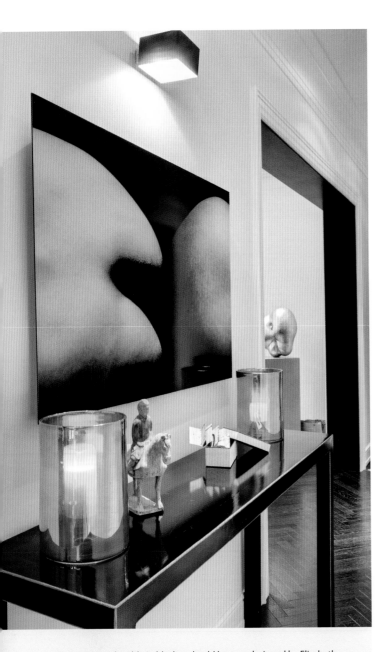

Above A console table in black and gold lacquer designed by Elisabeth de Brabant for her home. The raised edges and corners are sanded down to give the duotone effect. Displayed are glass Swedish lamps, a terracotta figure on horseback and a box of miniature handwoven Chinese paper books.

CONSOLES, ALTARS
AND SIDEBOARDS

Traditionally in the Chinese house, side (altar) tables were placed against a wall, and for this reason the side facing outward was usually more elaborate than the rear, and carved accordingly. The terms 'side table', 'altar table' and the more European 'console table' are these days used interchangeably, although traditionally they had specific functions. Altar tables, often in nested sets of two or three, held religious statues and objects and had a shrine-like function. Secular uses included holding musical instruments and displaying possessions of wealth and beauty, so it was important that the design of the side or altar table add sophistication when framed against a wall. Hand-carved scrolled edge and face embellishments played an important part in this, as did the everted curved flanges at each end. The side or altar table is usually long and narrow, perfect for an entry hall or corridor, or a living room accent. It exemplifies perfectly the subtlety of Chinese classical furniture, with the negative space being as important as the positive space.

Derived from this old tradition, a new generation of contemporary side tables and consoles display clean straight lines and eye-catching geometric shapes. They feature waisted construction and a floating panel top finished with elegant lacquer, and by taking space and simplicity into consideration they enable the visual focus to remain on simplicity of line and on the beauty of the materials used. In a practical sense, they are also perfect for keeping everything close to hand, and even provide valuable display sections for those attractive accessories and collections that the owners want on view.

Opposite above A Ming altar table used as a display for various Tibetan religious objects and a rootwood sculpture. On the floor is a rootwood jar used as a plant container and a floor-level writing desk.
Right A simple desk in stripped wood in the kitchen of gallerist Li Liang, three of whose ink/collages hang above.
Far right Set against a glass wall looking out onto the main courtyard of the Shao Fan house, one of the artist's constructions is a Ming altar table with everted flanges divided and connected by a Perspex section, on which are displayed ancient tomb figurines.

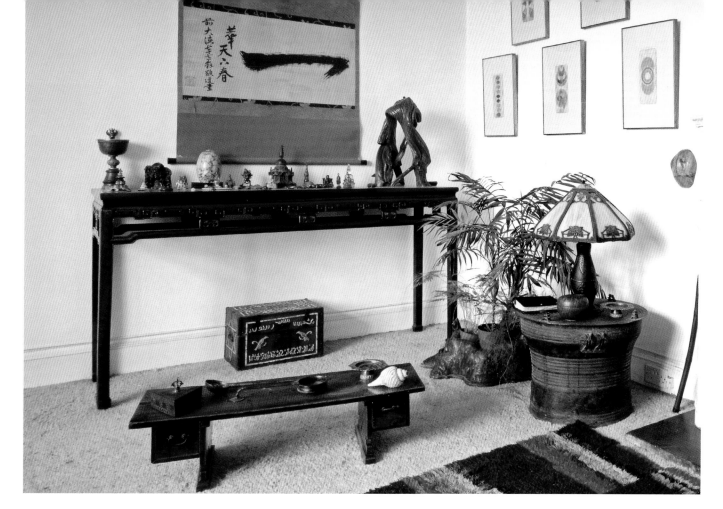

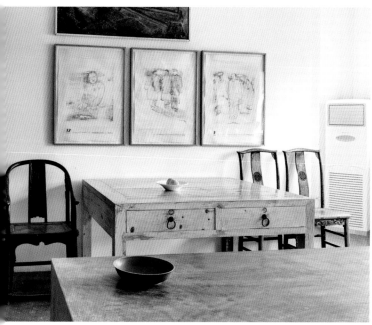

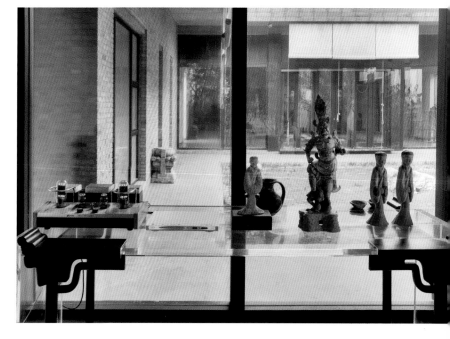

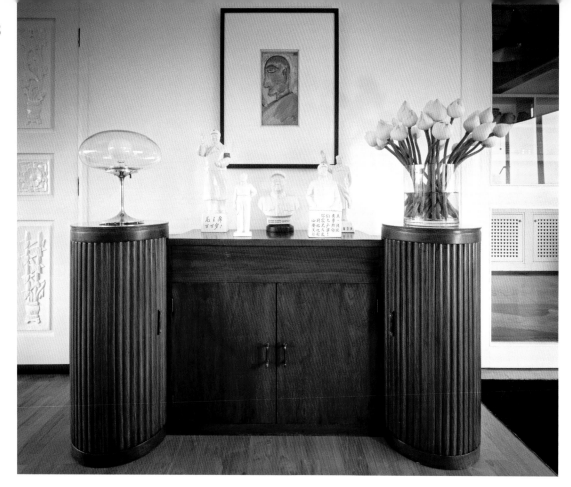

Above An Art Deco wooden side cabinet in the dining room of a modern apartment in Singapore, displays some of the white Mao Zedong figurines and busts in the owner's extensive collection.
Above right This classic Ming altar table with everted flanges, in *huanghuali* wood, forms a simple but elegant statement in an apartment entrance hall.
Right A small, ornately carved Qing side table is backed by a scroll painting of a tigress with cubs.
Center right A black and gold lacquer cabinet by Elisabeth de Brabant in front of a photograph by Wang Xiao Hui supports a hand sculpture.

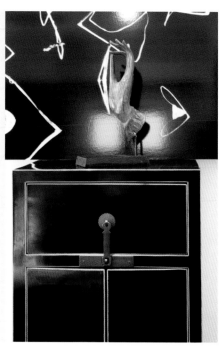

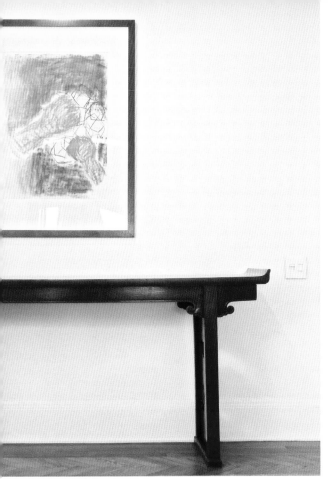

Above Below a classic eighteenth-century altar table, a colorful stool with similar flanges designed by Harrison Liu makes a playful contrast.
Left In this Hong Merchant *longtang* house in Shanghai, a nineteenth-century Korean chest with extensive brass fittings fills an under-stairs area, and carries a Neolithic Chinese jar and brush pots in wood and bamboo.

Right A Tibetan door cover, with mandala, from Lhasa used as a window blind in a Hong Kong apartment.
Below left A contemporary red-lacquered hinged Chinese screen inset with porcelain and round *bi*, at Pearl Lam's Contrasts gallery.
Below center A red-enameled curtain hook ties back heavy embroidered silk curtains.
Below right A Chinese rug backed and hung as a door cover.
Opposite above left A multi-paneled wooden screen in a geometric design.
Opposite above right and below Fabric window hangings from the Yunnan Mountain Handicraft Center in Zhongdian (Shangri-La).

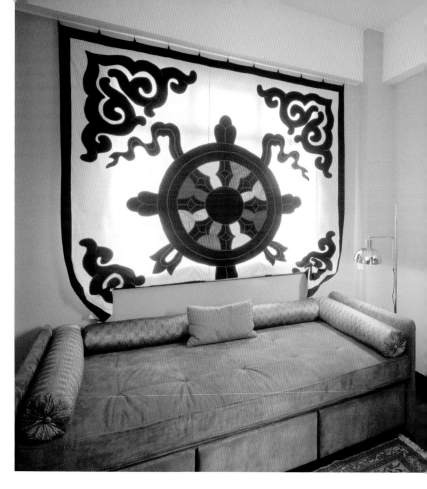

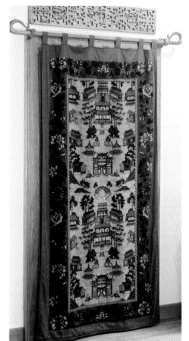

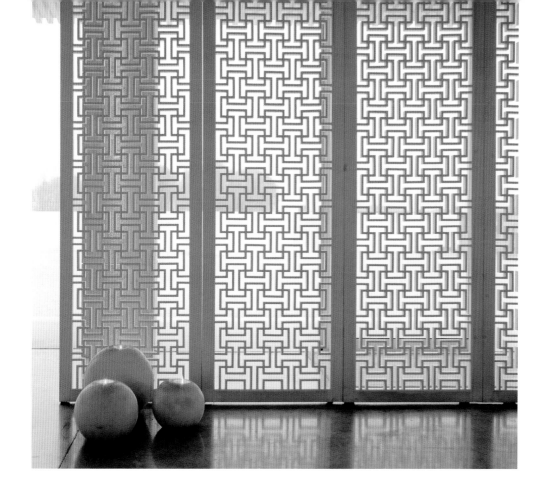

CURTAINS, BLINDS **AND SCREENS**

Screens played a very important part in the furnishing of Chinese households and two distinct types were common from early on in Chinese history. The first was the folding screen, usually made up of four or more hinged panels that could be configured in different ways. The second type was made from a large single panel set into a wooden stand. Placed on the floor, often around couches and daybeds, both types of screens were intended to provide privacy and protection, and often also accorded a certain level of status to their owners. The folding screens in current Chinese houses tend to be less traditionally decorative, often including innovative and aesthetic latticework which can be abstract and poetic, playing light and shadow. The contemporary folding screen at far left, in an intense red, is a notable example of evolution in design, with a strikingly pillow-textured face in lacquer and decorated with simplified Chinese traditional elements. The curtains in Chinese and Tibetan house interiors take the role of protecting the interior from view and of preserving warmth and privacy. There are many variations of curtains for interior design, according to the owner's taste and feeling. For the classic style, gold, red and green or floral patterns are characteristic. By contrast, there is another type of simple, original or natural design in materials such as linen.

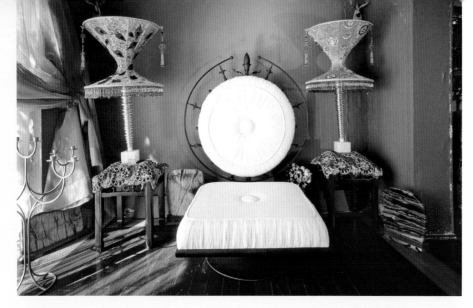

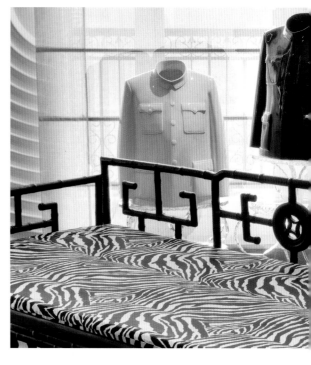

Above Chinese themes inspire contemporary furniture in Pearl Lam's Hong Kong house, including a white upholstered Throne Chair by Mark Brazier-Jones and embroidered and jeweled lampshades by Franck Evennou.
Below An armchair converted by Shao Fan from an antique Tibetan chest and upholstered in sheepskin. In front is a Tibetan tiger rug.
Opposite above center A Qing open-back daybed upholstered in zebra stripe fabric, with black and white versions of Beijing artist Sui Jian Guo's fiberglass 'Mao Jacket'.

Opposite above right 'YinYang' chair-stools designed by Harrison Liu. The same basic construction, inspired by yin and yang duality, is used for the table on page 39.
Opposite below center A white-painted wooden slatted chair designed by Yu Yongzhong of Banmoo.
Opposite below right A contemporary steel interpretation of a Ming spindle-back chair.

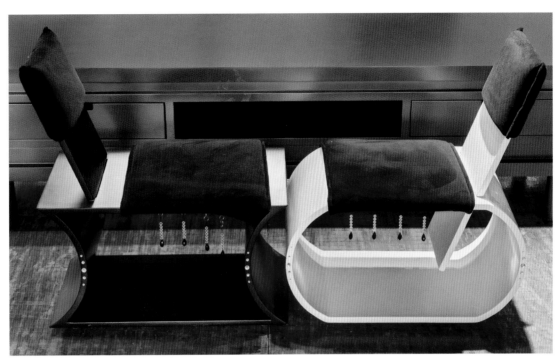

CONTEMPORARY **AND RETRO SEATING**

Despite the power and elegance of traditional Ming and Qing style furniture, and the ways in which it can complement modern interior spaces, there is plenty of scope for using newer designs to accentuate and even carry a particular design style. With relaxing and unwinding being now such important features of home life, the sofa assumes a new significance, and contemporary sofas are designed to combine some features of the couch, the chaise longue and the daybed. Unlike the sofa's role in creating comfort and luxury, chairs have tended to be designed by reviving traditional Chinese themes and putting a contemporary twist in them, either playfully or with a view to more functionality. They are more and more the outcome of explorations into how art and design can be inserted successfully into the best aspects of traditional Chinese culture, at the same time keeping everything firmly within a modern context. In this sense, many of these chairs can be regarded as sculpture or conceptual art, while maintaining their function as furniture. On the following two pages we can see another trend, which is to revive the increasingly popular Shanghai Art Deco and other styles from the twentieth century. Adopted Western styles from the 1920s through to the 1950s have themselves acquired a Chinese aura, by adaptation and by the contexts in which they have been seen and used.

Right In the restored Mullinjer House in Shanghai, bespoke de Gournay wallpaper is based upon seventeenth-century Western paintings depicting Chinese landscapes. Portraits of the owners and their architect have been added to one of the garden scenes. Below Reproduction 1930s Shanghai leather-upholstered seating. Above hangs a 2009 'Neck' painting using real hair by French artist Christian de Laubadere.

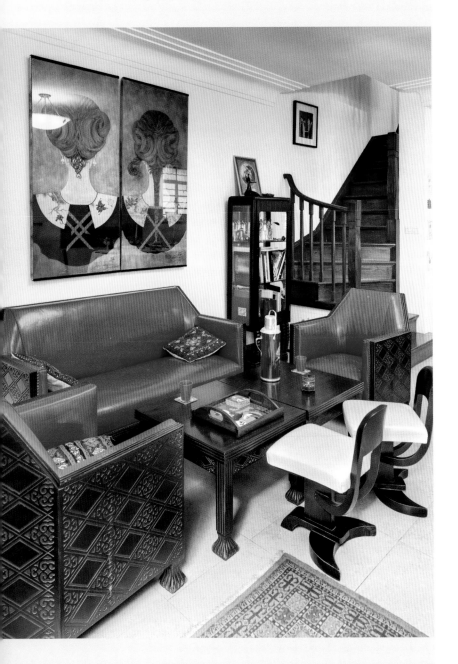

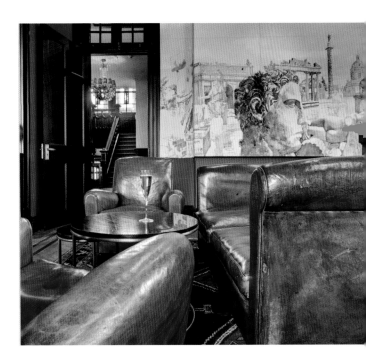

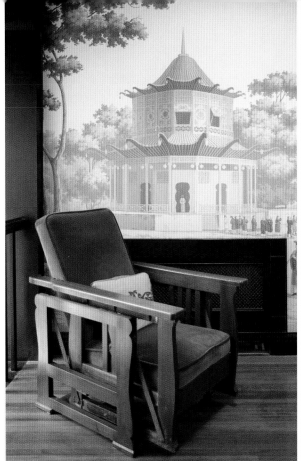

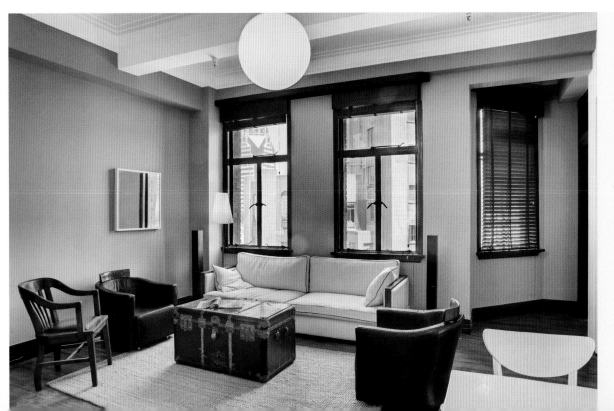

Above A 1940s armchair uphol-stered in green fabric with a contrasting red cushion, below a Shanghai cigarette poster from the 1930s.
Above left A reclining colonial chair on the landing of the Mullinjer house in Shanghai.

Left A pair of 1930s black leather armchairs and a nineteenth-century Chinese chest in an apartment conversion in the famous 1934 Hamilton House, near the Bund in Shanghai.
Center left A 1930s Shanghai leather sofa and armchairs at the Kee Club, a private members' club housed in the Twin Villas, a neo-classical property on Huaihai Road.

FURNISHINGS AND ACCENTS

CONCEALED **STORAGE**

The art of containment has a long history in East Asia, with China the ultimate source. This covers a wide range, from packaging to storage, and all of it shares a common aesthetic background made up of economy, ingenuity and the appropriate use of materials. This has never disappeared from Chinese design, although the form it takes has changed—and continues to change. There is nowadays, if anything, an increased need for maximizing the use of living space as more Chinese move to the cities and deal with ever more restricted space. The three examples here give a glimpse of the kind of solutions that are now being employed, particularly in apartment dwelling. Behind it all is the very Chinese principle of addressing the task of designing for functionality, but with an elegant touch. Eschewing ostentation, classical Chinese house design tends towards neatness, order and low-key refinement, and ingenious concealed storage ideas contribute to this. Multiplicity of function is the order of the day. Going beyond simple concealment, ideas such as these provide, for instance, a floor-to-ceiling door that is all at once a cupboard enclosure, a partition wall and a dressing mirror, sensibly located by the front door. In another case, the enclosure becomes a well-lit display arrangement.

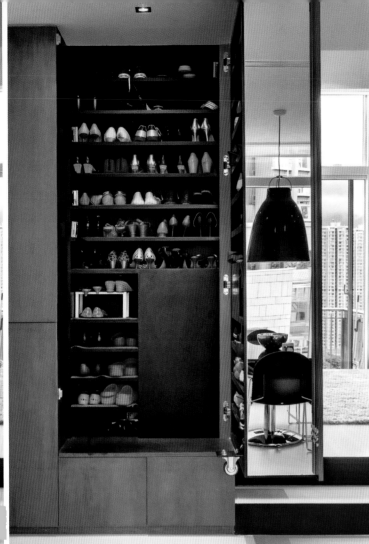

Left and far left A concealed storage unit just inside an apartment entrance. When closed it is a divider with a display niche, when open it reveals shelving, a cupboard and a dressing mirror.
Below and bottom This wood-paneled wall, with two lit niches containing scholars' rocks, provides both concealed storage and access to the kitchen and stairs.

Left and far left At the entrance to another Hong Kong apartment, a concealed storage area contains shelves for clothes as well as a full-length dressing mirror.

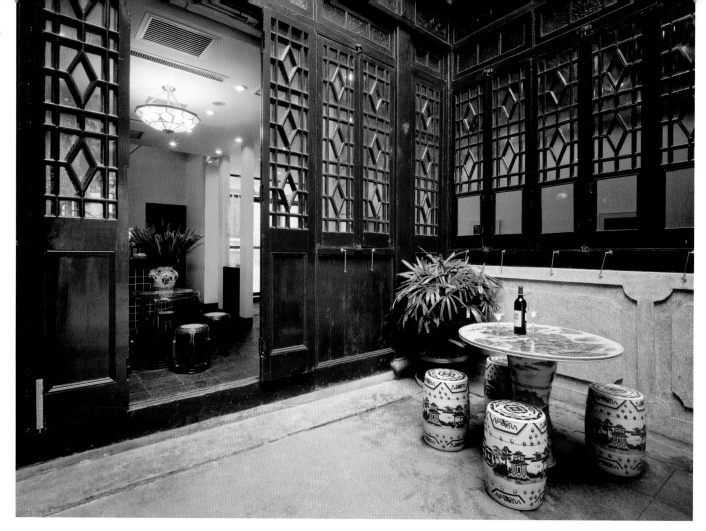

DRUM STOOLS

Suitable both as a sturdy seat or as a display stand for plants or other decorative items, the Chinese drum stool has become a popular element in decor, and not only in China, where it is considered a distinctive Chinese design icon. Drum stools have been part of the Chinese tradition for at least a thousand years, and records of them in use date to paintings of the Song dynasty (960–1279), where they can be seen as casual seating both indoors and outdoors. No actual stools survive of this age; most antique stools come from no further back than the late Ming dynasty. Although almost always made of blue-and-white or multicolored porcelain, some drum stools are handcrafted by artisans known for dazzling lacquerware and woodcarving. Others are made of brass, which is antiqued and finished to resist rust. On all, the characteristic nail-head motif around the upper and lower rim recalls the original construction, in which, exactly like drums, skins were secured as seating over the barrel structure. The decoration of most drum stools is based on traditional designs steeped in ancient Chinese history. Many exhibit common natural and cultural motifs, often adapted from ancient and well-loved art themes. The motifs include birds, animals and flowers, and sometimes tell stories or poems, adding a lyrical element to the simple beauty of the design.

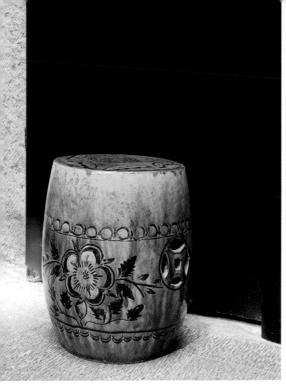

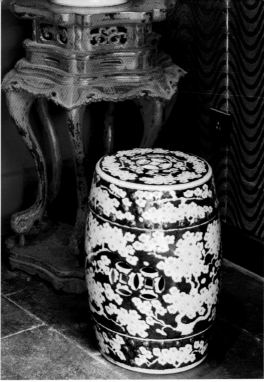

Left The courtyard of an old Shanghai *shikumen* (stone gate house) with a set of blue-and-white hexagonal porcelain drum stools arrayed around a ceramic pedestal table.

Above An antique stool in a rich blue-green glaze inside the door of a *shikumen* in Shanghai.

Above center A drum stool used indoors, in traditional blue-and-white.

Above right An antique gold-and-black painted wood hexagonal rice canister in the form of a drum stool and intended for casual seating.

Right In the corner of a kitchen, a white porcelain drum stool next to a metallic finish table.

Far right A contemporary ceramic stool with a metallic silver finish.

Below The dining area of a modern Chinese apartment, Mid-Levels, Hong Kong. The chairs are faux bamboo, carved in a once-popular style from wood.
Bottom left A Chinese bamboo reclining lounger with retractable foot stool.

Bottom right A chunky provincial-style bamboo sofa used as an endboard for a bed.
Right An antique provincial bamboo kitchen cabinet with open and closed storage spaces.

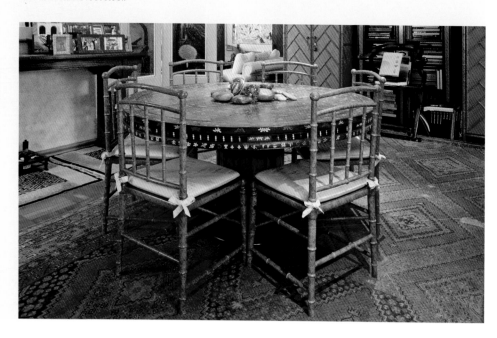

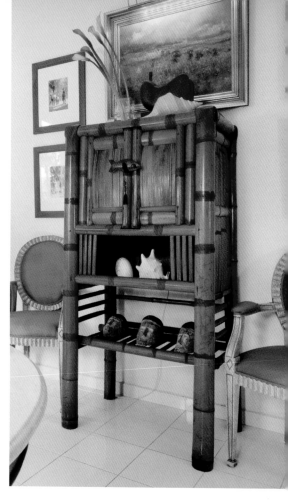

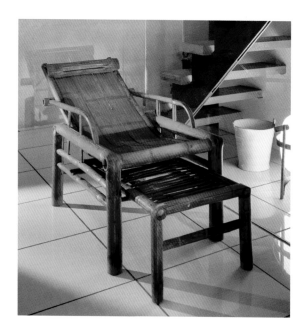

BAMBOO AND RUSTIC FURNITURE

Bamboo has a long history of use in Chinese furniture. It also has a distinct style based on millennia-long traditions. The plant's long life makes it a Chinese symbol of longevity, while the rarity of its blossoming has led to the plant's flowers being regarded as a sign of impending famine. In Chinese culture, the bamboo, plum blossom, orchid and chrysanthemum are collectively referred to as the Four Gentlemen. These four plants also represent the four seasons and, in Confucian ideology, four aspects of the Junzi ('prince' or 'noble one'). As for the way in which pieces of such bamboo furniture are used, they serve as armchairs, spare seating, stools, cabinets and even baby carriages, indicating the natural part of everyday life as well as a casual attitude. Even though commonly seen as convenient and expendable objects, the elegant yet unconstrained aspects of bamboo furniture throughout history have always been valued. At the same time, such furniture can be seen being used by Zen priests and Confucian scholars, evidencing a historically ascetic and unconventional side. Nowadays, the use of bamboo furniture is more and more popular in Chinese houses, and has come to coincide with an image of a certain contemporary lifestyle that yet harks back to a rustic and honorable tradition.

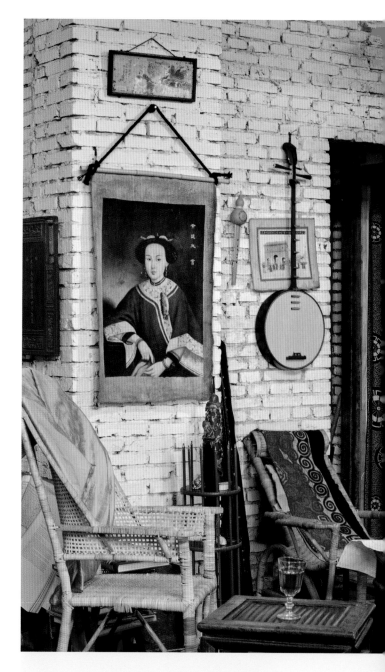

Top left Two eighteenth- and nineteenth-century Beijing glass pendants function as doors pulls on a bamboo cupboard.
Above Simple locally made bamboo chairs furnish the eclectic sitting area of an artist's atelier in Shanghai.

Above, from left to right A bedside lamp converted from an old gas lamp and a 1920s radio. A lighting unit constructed from an array of industrial caged lamps in a Suzhou Creek converted warehouse, designed by Deng Kun Yen. A cluster of red fabric lanterns with tassels suspended from the ceiling of a vestibule. A backlit onyx-fronted counter with, behind, shelving on a bare brick wall holding candles in frosted glass cups.

Right A Hmong silver wedding headdress converted into a light fitting.

Below A wall light in beaten metal in a villa designed by Belgian architect Jean-Michel Gathy at Fuchun, Hangzhou.

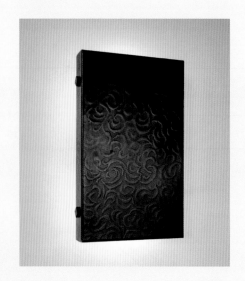

LIGHTING

Traditional Chinese lamps have been around for over 1,500 years and were used in the Emperor's court right up until the introduction of modern electrical lighting. Traditionally with a white base, these lamps are often covered with distinct Chinese designs and varied calligraphy. Antique Chinese lamps in combination with modern design make great living room and bedroom decoration in addition to lighting functionality. An ancient symbol in Chinese history, the lantern represents many things. Those with a lotus shape or pattern, in particular, symbolize illumination and knowledge in Buddhism. Poems and riddles were often inscribed on them. Pagoda-style table lamps can be superb decorative ornaments even when they are switched off, as such classical lamps contribute to a Zen atmosphere. A number of contemporary lighting designers take inspiration from classical light features in creating new works, whether in an industrial aesthetic, or in a beaten brass shield for concealed wall lighting, or a playful use of an ethnic minority wedding headdress. Abstracting in these ways, the lamps in today's design arena come in diverse shapes and sizes that include striking pendant lights, table lamps, centerpieces and garden decorations, and in materials ranging from paper spheres to intricate metal and wood frames lined with fabric.

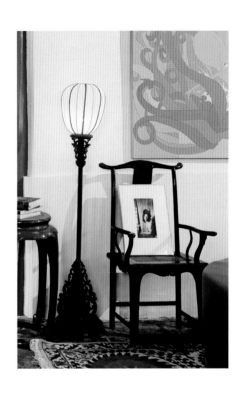

Above A wooden nineteenth-century Chinese standard lamp and yoke-back chair.
Far left The mount of this hanging red cloth lantern follows a traditional cloud spiral design.
Center left A steel Art Deco lamp in a geometric design with red enamel decoration.
Left A stained-glass window and wall lights in the Twin Villas, Huaihai Road, Shanghai.

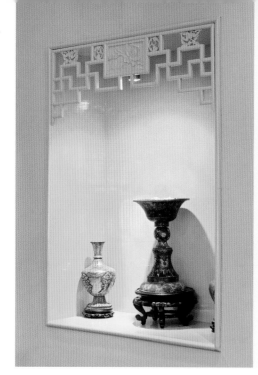
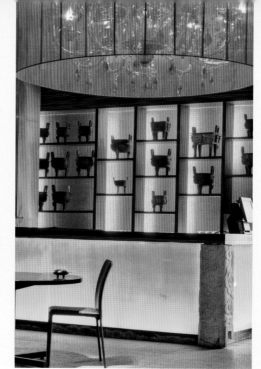

ALCOVES, NICHES AND DISPLAYS

As we have seen earlier, the popularity of long, narrow altar tables, both historically and today, has much to do with the Chinese love of displaying treasured or aesthetically pleasing objects. Of even more variety in fulfilling this function are alcoves and niches—essentially decorative spaces built into walls to add visual interest and as storage space for items that are of sufficient interest that they do not need to be kept shuttered away. Alcoves, which are of course larger, can be put to a number of uses, and for display, as shown in the examples here. They allow furniture units to sit back clear of the principal floor space. They also present a kind of frame that focuses attention. One adaptation, as shown at far right, is to combine their decorative potential with a function as occasional seating—here for serving an individual pot of tea. Niches have even greater variety of form—rectangular or arched, deep or shallow—and tend to be used more for displaying small objects. When the shape of the object matches that of the niche, or is in proportion to it, the display achieves a particular success.

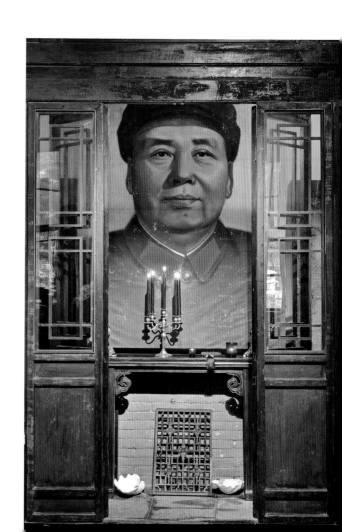

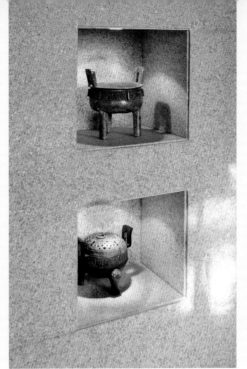

Top, from left to right A niche with built-in downlights and an upper openwork wooden frame. Behind a bar supported at the corners by stone Ming columns, a backlit display case features a collection of *ding* (antique cooking vessels with three or four legs). In designer Kelly Hoppen's apartment, two narrow, rectangular display niches, each with a concealed downlight, highlight single stemmed lilies in slim clear glass vases. Calligraphy and a stone statue of Guan-Yin in a circular wooden shrine cabinet in an alcove. Niches set into a stone column display antique bronze *ding* vessels.

Below left An alcove with a poster of Chairman Mao in a Beijing residence converted from a Ming temple.

Below center A pair of teak doors with stained-glass panels, salvaged from an old mansion about to be demolished, have been turned into an alcove in an entrance hall.

Below An alcove in a vestibule fitted with bench seating where guests may take tea.

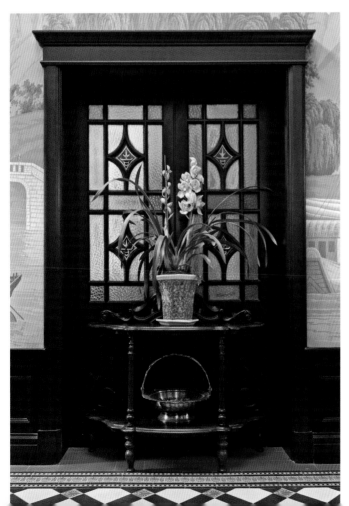

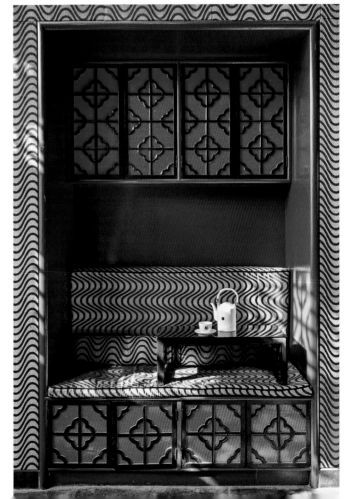

Left A Ming table cast in metal by Chinese artist Shao Fan, in his studio and home on the outskirts of Beijing.
Below left Seasonal fruits in a bowl are displayed on an alcove shelf next to the kitchen of a Beijing apartment.
Below center A flower shelf supports a polished river stone set in a backlit alcove against a wall of sandblasted glass.
Below Downlights illuminate three flower vases in a niche over the fireplace of designer Kenneth Jenkins' house in Shanghai.

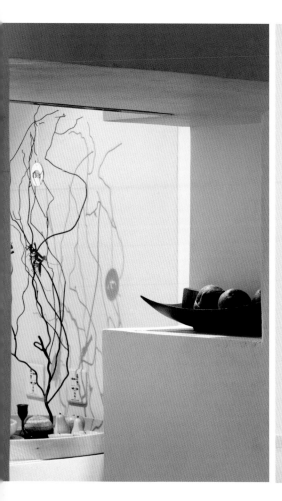

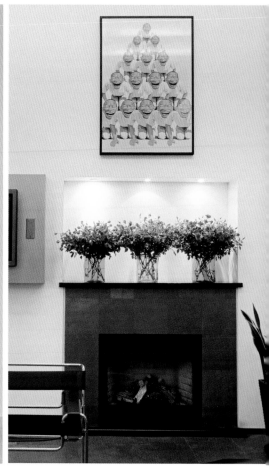

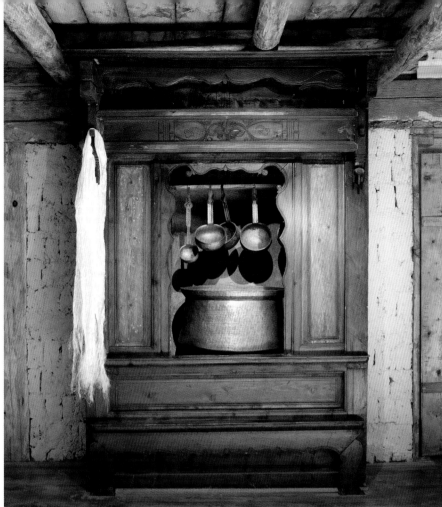

Above left A connecting door, no longer used in the conversion of the Shanghai Japanese consulate into apartments, has been turned into a cupboard by inserting plain wooden shelves.

Above In the Malik house in Zhongdian, Yunnan, the central wooden unit in the entrance hall houses a traditional Tibetan copper water jar with brass ladles. A silk Buddhist scarf hangs at left.

Left Shelving in a Qing study contains objects typical of a scholar's collection.

Right A circular glass display cupboard with shelving, dating from the 1930s, in an old Shanghai villa.

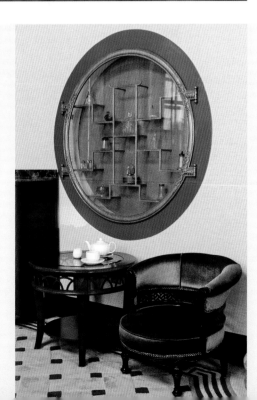

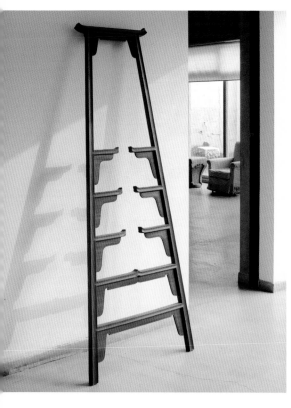

Above from left to right One of Shao Fan's furniture-inspired artworks, 'Ming Ladder', 2006, in chicken wing wood, in which the rungs separate as they rise, turning into profiles of a raised flange table. Small display stands in the form of miniature high chairs, with a miniature vase, designed by Yu Yongzhong. A drinks cabinet with mirrored lid designed in the form of an old Chinese trunk by Harrison Liu.

Opposite top An antique blue and green glass dragon plaque used as the grip on a sliding glass door.

Left Chinese cabinet metal door pulls in the shape of fish.

Right, from left to right The ornate headboard of a bed from Pearl Lam Galleries. A detail of a glass and stone table featuring the 'cracked-ice' design and a dragon by Shanghai artist Sun Liang, at Pearl Lam Galleries. Bamboo bowls in the kitchen of the Laetitia Charachon lane house. Knife holders in the form of boxes packed with long slivers of wood. Marble and jade underplates (*yupan*).

FURNISHINGS AND **DETAILS**

We finish this chapter with a medley of ideas that draw on Chinese culture and tradition. The images along the top row are all in some way adaptations, from an antique dragon roundel in glass re-purposed as a door slider, to a chest based on the tradition of a marriage box designed as a drinks cabinet. Designer Yu Yongzhong takes Ming chairs as the inspiration for miniature stands, exaggerating and elongating them, while artist Shao Fan deconstructs a traditional Ming ladder and turns it into a work of art, acknowledging at the same time that original antique versions are now more usually displayed without function. Other details enhance decor with their cultural and philosophical associations. For instance, the *ru yi* has been a symbol of abundance and wealth from the time it was carried by powerful Imperial Chinese officials. With contemporary design, the pattern of *ru yi* has been re-engaged in a variety of objects and with different materials. Likewise the paired fish commonly appearing on lock plates of cabinet doors are propitious symbols; in Chinese philosophy, they signify that good things should come in pairs.

COURTYARDS, GARDENS AND TERRACES

The courtyard has long been central to the concept of Chinese living, both as a way of ensuring family privacy, as we saw at the beginning of the book, and as a way of bringing nature into the home. The latter has deep philosophical roots, because in traditional Chinese thought things are considered in their entirety, which has led to the practice of representing the larger world in microcosm. This conception of nature affects the way that Chinese visualize the spatial structure of landscape, encapsulating a world-view in their physical representation of space. The works of many Chinese literati—scholars, poets, calligraphers and painters—bear witness to the power of landscape in the intellectual as well as aesthetic consciousness of the cultural elite, bearing witness to the interconnectedness of immanent life and the world.

The Chinese traditional garden and courtyard operate on several layers of significance in relation to the larger landscape, restructuring and reconstructing nature according to the human scale as well as ideological conditions. It largely consists of symmetries that define a center which, in turn, delineates motion, so that the experience of walking across or through a courtyard or garden replicates movement through the landscape. This, in turn, implies one's progress to enlightenment or knowledge.

What was emphasized by the designers of the private courtyards and gardens was the appreciation and creation of natural scenery. They pursued the special pleasure of enjoying the beauty of nature without leaving one's house. The spaces available in contemporary homes for reproducing nature in microcosm are generally smaller, but nevertheless today's designers employ a wide variety of techniques in order to arrange and expand the visual space—winding and covering, hiding and revealing, closing and opening, separating and borrowing—to raise visitors' awareness of the aesthetic use of space.

The courtyard garden of the old Suzhou Museum, a former palace, in Suzhou, the traditional center of Chinese culture, in particular of Chinese gardens, for which this city is famous.

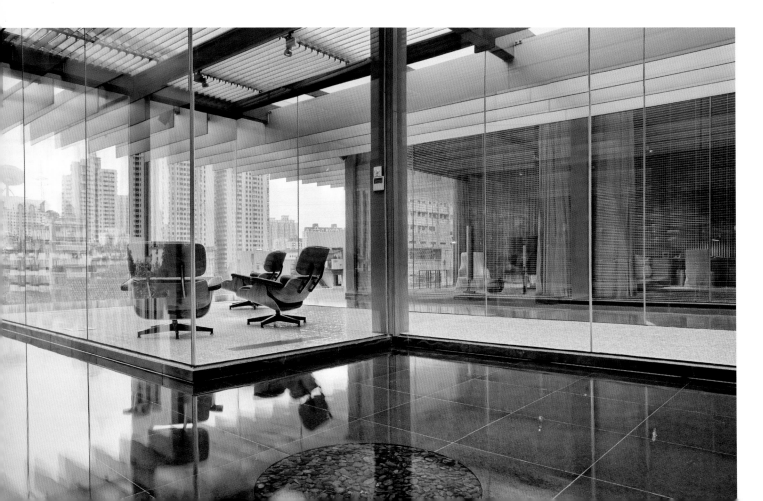

WATER **COMPONENTS**

Water plays a common part in gardens throughout the world for its sound and for enhancing the sense of nature brought into the home, but in China it has an important and very particular philosophical role in the form of Feng Shui. This system of aesthetics, when applied to a house and garden, uses geomancy to direct the flow of *qi* or energy in the sense of 'life force'. The aim is to improve one's life and create harmony, and the English translation—'wind-water'—is taken from an often-quoted fourth-century text: "Qi rides the wind and scatters, but is retained when it meets water." In garden design, water skills are among the highest in Feng Shui, because the arrangement of still and moving water (ponds and basins, streams and fountains) directly affects whether *qi* is captured and accumulated, or allowed to disperse. Naturally, water is of key importance in relation to the courtyard. The water body also has the benefit of blending a house with its surroundings. The view of water from within and around the house is important for its calming sensation, and for the dual effect of helping to interpenetrate exterior and interior, nature and dwelling.

Above A concrete water spout in the courtyard pool of a large property on the outskirts of Shanghai.
Left The terrace, with private hot spring pool, of a villa on an old forested slope overlooking the Jialing River, near Chongqing.
Opposite above Contemporary built but respecting tradition, this reflecting pool flanked by low shrubs provides a peaceful separation between buildings in a villa complex near Hangzhou.
Opposite below Architect Kengo Kuma takes nature to the top by building an infinity pool surrounding the glassed-in sitting area of a penthouse apartment in central Shanghai.

THE COURTYARD **TRADITION**

The courtyard is at the center of the Chinese tradition of dwellings, and in a sense the surrounding wings of the house, looking into the courtyard, were subordinated to it. A substantial dwelling would have a series of courtyards, increasing in privacy and intimacy away from the main street entrance. Modern houses offer less spatial opportunity for this, but nonetheless the key two features of a courtyard are, first, its enclosing character that creates privacy and tranquility and, second, its role of bringing a miniature version of nature into the home. Plants, water and stone all play a part in this. Interior courtyards in traditional Chinese houses tend to exhibit the vernacular, with brick, cobblestone and cement paving stones common choices to create the ambience of a courtyard, and with furnishings and decorative touches that might include carved window latticework, rustic bamboo and drum stool seating and a neutral and natural palette with occasionally a touch of red. A simple bench under a decorative framework, as in the village house below, allows a feeling of serenity and contemplation. As urban living grew in the nineteenth century, home owners were compelled to adapt to the noisier and more crowded conditions, as we can see in the examples on the facing page.

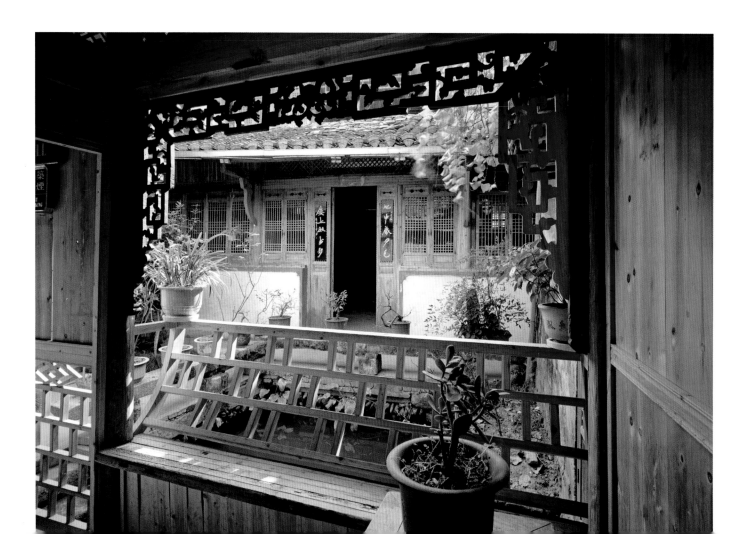

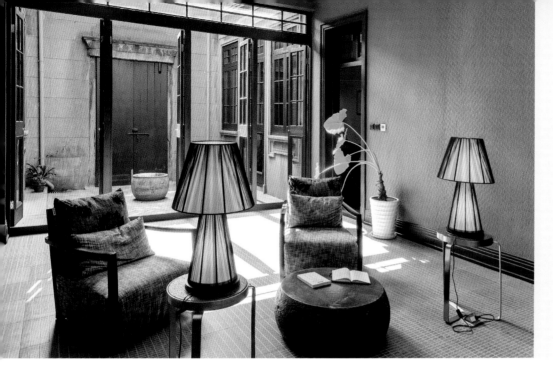

Left A view from the living room to the courtyard, with French windows opened, in a late nineteenth-century *shikumen* (stone gate house) in Shanghai. The large gate that gives this kind of house its name is on the far side of the courtyard.

Below left Low bamboo chairs in the courtyard of the Shikumen Wulixiang in Xintiandi, Shanghai.

Below center Casual seating in the central courtyard of a restored *hutong* dwelling in Beijing, with a table set for tea.

Below Another, larger Beijing *hutong* dwelling, with semi-open walkways around each courtyard, fitted with occasional seating.

Opposite below A bench with projecting backrest opens onto a courtyard garden in a house in the traditional village of Hongcun, Anhui Province.

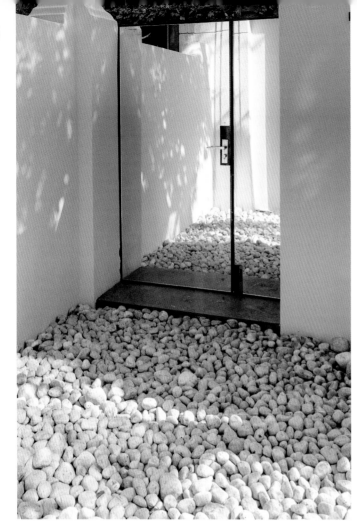

CONTEMPORARY
COURTYARDS

The Chinese courtyard is, above all, a place of privacy and tranquility, almost always incorporating a garden and water feature. Nowadays, more and more Chinese architects are investigating ways in which courtyards can play a role in the development of today's homes and cities. In densely populated areas, a courtyard in a home can provide a break from the frantic pace of everyday life, and a safe place for children to play. With space at a premium, architects are now experimenting with courtyards as a way to innovate. In contemporary versions of the Chinese home, the courtyard in architectural language is conceived as an interlocking series of contemplative and inward-looking spaces, helping to separate the house from the outside world by gently defensive elements, such as low stone walls and shallow pools. Yet, it also has openness and permeability. Because courtyards, even the smallest, are essentially part of the structure of the building, there is an increasing variety of materials being used. There are new ways with brick, using different colors, and also concrete with a variety of formwork, some of it exposed, such as wooden planking. Contemporary courtyards tend towards simplicity, even minimalism in what they contain, compared with, say, the Ming and Qing classical courtyard gardens of Suzhou. The placement of one or two stones, for example, achieves an almost Zen-like contemplative simplicity.

Above left Mirror-faced doors at the back entrance of a terraced lane house extend by reflection the white pebble covering of the small, minimalist and low-maintenance garden.
Left Stone lions at the entrance to a contemporary Beijing courtyard garden.
Above right The side garden of a contemporary Beijing house, given a sense of identity as a courtyard by the open steel frame, has a wooden floor and features a large Taihu rock, which is a common type of ornamental stone used in traditional Chinese gardens.
Right The garden of the de Brabant house contains marble sculptures by artist Wang Xiao Hui, from her 'Erotic Fruits' series.
Far right In the courtyard of China's most famous artist, Ai Weiwei, winter pumpkins are arrayed on a concrete bench designed by the artist.

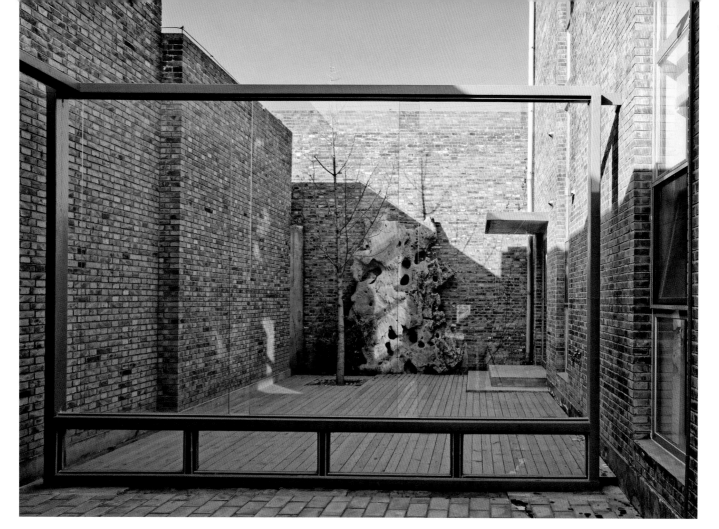

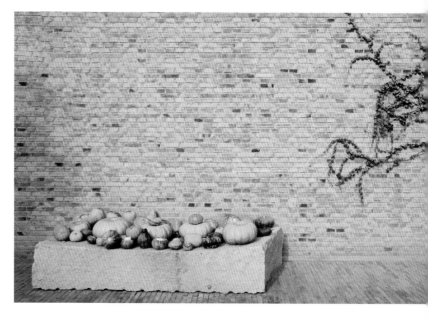

COURTYARDS, GARDENS AND TERRACES

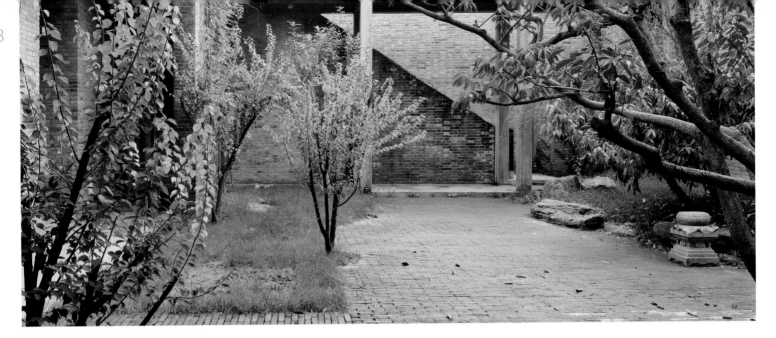

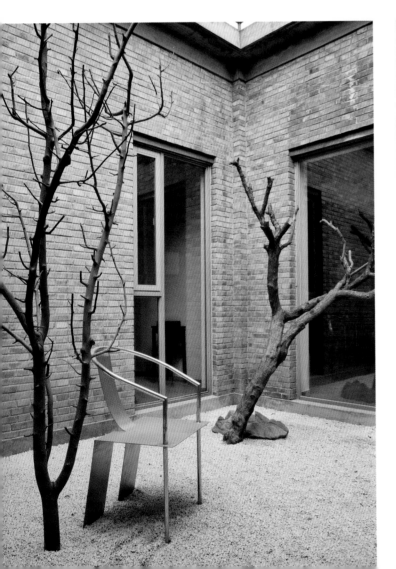

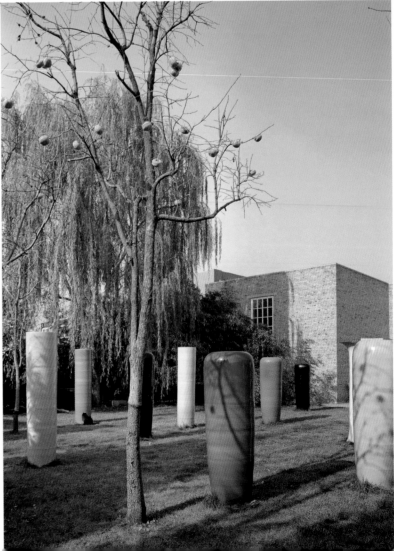

Left Another courtyard garden in the Shao Fan house.

Opposite below left One of the nine gardens, reflecting traditional Taoist philosophy, in a Beijing courtyard house. A steel garden seat mimics Ming style.

Opposite below right The large garden of Ai Weiwei's house, also shown on the previous pages, is used to display some of the artist's largest artworks, here a series of tall porcelain vases.

Right The view to the main courtyard of Shao Fan's residence from the entrance area. The chair, the best known of Shao's seating designs, is a deconstructed piece of furniture, 'exploded' and held together with sheets of clear acrylic. The chair appears to be frozen at the moment of explosion, with the wooden elements hovering in mid-air.

Below right In one of the garden courtyards of architect Deng Kun Yen's studio, a moongate built of recycled bricks at left is reflected in an effective illusion by a large mirror wall at right.

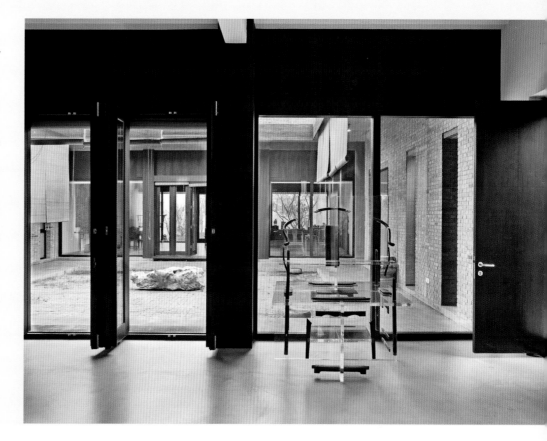

Opposite above A display of rocks in the form of *penjing*, or miniature landscape, in the Humble Administrator's Garden (Zhuo Zheng Yuan), Suzhou.

Opposite below left and right World-renowned architect I. M. Pei, whose early family garden is shown below, installed ranks of peaked stones in this large Suzhou garden to represent ranges of hills.

Above A garden sculpture and a massive ornamental stone in the center of a compound of villas on the outskirts of Beijing.

Right A limestone rockery with intermingled plants and pond occupies one corner of the city garden of the 1930s Pei mansion in Shanghai.

THE SPIRIT OF **STONE**

Stone is likened in Chinese thought to the lifeblood and structure of the world. The typical showcase of stone in a traditional garden is a rocky hill, artificially and artfully composed from a composition of individual rocks that snake and zigzag, spiraling upwards and downwards, encircling, overlapping and embedded, giving a rich and complex feel to the structure, as well as forming a unique Chinese sculptural tradition that is both aesthetically sophisticated and as deep in meaning as more conventional sculpture. Although small, the rocky hill has a maze of paths, caves, running streams, stone chambers, secluded ravines and surging peaks. A second tradition, that of the miniature landscape or *penjing*, interconnects with this. Although it commonly features miniature trees (bonsai is derived from this), it also includes stones chosen and arranged for their replication of landscape. In contemporary Chinese garden design, space limitations and a more modernist approach generally demand fewer stones to represent the same philosophy. What the painter Shi Tao wrote about traditional Chinese ink paintings might well be paraphrased to describe these stones: "Some leaning upward and others leaning downward, some slanting and others leaning, some gathering and others separating, some near and others faraway, some inside and others outside, some false and others true full, some broken and others connected, some open and others closed, some vaulted and others standing, some squatting and others jumping, some majestic, some gorgeous, some steep, some precipitous, some hierarchical, some stripped, some charming and some barely discernible."

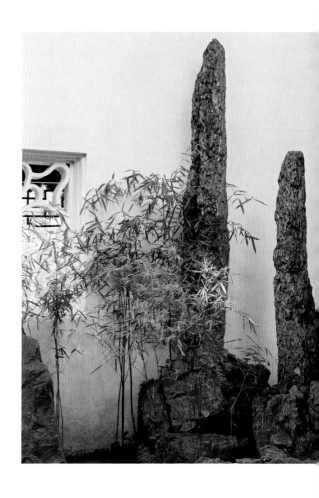

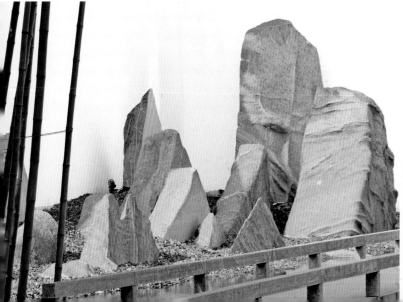

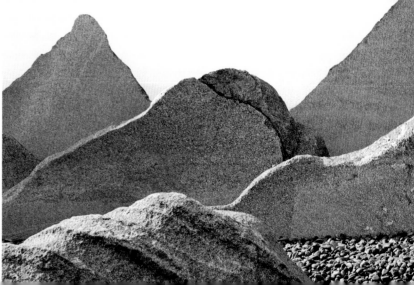

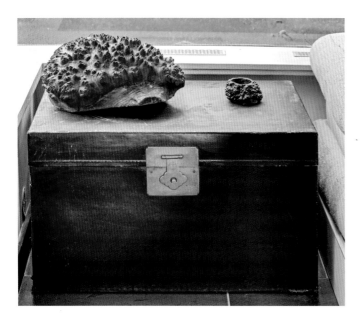

SCHOLAR'S ROCKS AND
ROOTWOOD

The large garden stones that we saw earlier have a miniature expression in the form of *wen renshi* or scholar's rocks. Also known as *gonghsi*, meaning 'spirit stones', these vary in size from those that will sit on a desk or side table, as below, to small versions of Taihu stones, generally tall, that can be the centerpiece of a room, as at right. These are contemplative objects, and since the Song dynasty have been collected. When scholars (*wen ren*, hence the name) formed an important element in Chinese society and culture, stones were an essential fixture of a study. The fantastic shapes of the most sought-after stones are considered to resemble mythical animals, legendary landscapes and Taoist grottoes, and as such have symbolic meanings. The shapes are analyzed in four categories: thinness, openness, holes and wrinkling. As rocks, they were considered indestructible and therefore a symbol of longevity, and fundamentally as representations of nature brought into the home, with Taoist references. For the same reason, wrinkled and polished rootwood has long had the same attraction for Chinese. Rootwood is typically fashioned into usable objects, such as the vases shown here.

Above A spectacular natural found rootwood sculpture on a side table by artist Danny Lane, in the Pearl Lam apartment.
Below Rootwood resembling a hedgehog on a Chinese leather chest.
Below right A scholar's rock on a rootwood stand, with brass-edged box, in the Ellsworth apartment, Manhattan.

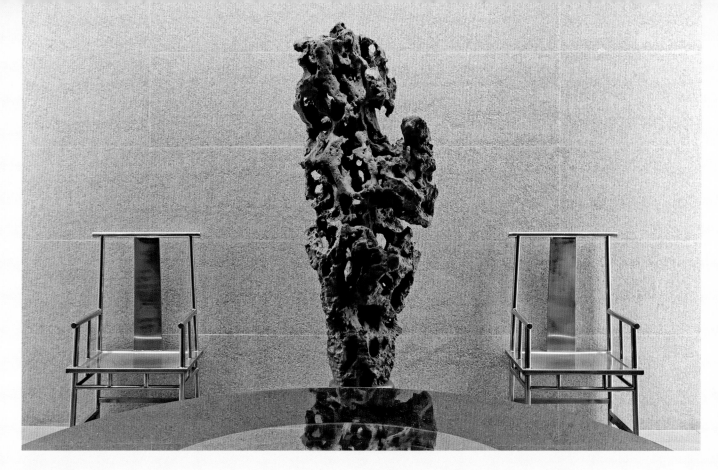

Above A tall scholar's stone on a pedestal and two steel chairs referencing Ming designs.

Below left and right Polished rootwood vases with plants.

ACKNOWLEDGMENTS AND SOURCES

Our thanks to the following, both the designers and architects whose work we show, and the home owners who generously opened their houses to us:

Ai Weiwei
Alec Stuart
Anderson Lee, Index Architecture, Hong Kong
 www.indexarchitecture.com
Bernard Chang
Carole Lu
Carter Malik
Christian de Laubadere
Cyril Gonzalez
Debra Little
Deng Kun Yen
Elisabeth de Brabant
Fred Kranich
Ghislaine and Hervé Bouillet-Cordonnier
Grace Wu Bruce
Hong Huang
Jack Bulmash and Michael Schur
Jehanne de Biolley and Harrison Liu
Jin R
Johnny Li
Kai Yin Lo
Kelly Hoppen
Kengo Kuma
Kenneth Grant Jenkins **www.jkarq.com**
Kush Living, Hong Kong **www.kushliving.com**
Laetitia Charachon, Platane Home & Lifestyle,
 156 Taikang Lu, 200025 Shanghai
 laetitia@platane.cn
Louise Kou
Ma Yang Son
Max Chang
Michael Fiebrich
Miho Hirabayashi, FAK3, Hong Kong
 www.fak3.com
Mimi Lipton
Miranda Rothschild
Pan Shiyi and Zhang Xin
Pearl Lam
Robert Ellsworth
Rocco Yim

sciSKEW Collaborative **www.sciskew.com**
Shanghai Banmoo Furniture
 www.BANMOO.com
Shao Fan and Anna Liu
Shigeru Ban
Sue Shi and Steve Mullinjer
Sui Jian Guo
Wang Jie
Yue Min Jun
Zhang Huan
Zhong Song
Zhong Ya Ling, Ya Ling Designs
 www.yaling-designs.com

For sourcing and introductions, we are indebted to Sharon Leece, Vivi Ying He and Xiao Dan Wang.

Thanks also to the following galleries, hotels, clubs and museums:

Brilliant Resort and Spa, Bei Bei
 www.brilliantspa.com
Brilliant Resort and Spa, Yangzonghai, Kunming
 www.brilliantspa.com

China Club, Hong Kong **www.chinaclub.com**
DuGe Hotel, Bejing **www.dugecourtyard.com**
Elisabeth de Brabant Art Center, Shanghai
 www.elisabethdebrabant.com
Fuchun Resort, Hangzhou **www.fuchunresort.com**
Hong Merchant, Shanghai
 www.hongmerchant.com
Hotel Jen **www.hoteljen.com**
Ke Tang Jian, Shanghai **www.ketangjian.com**
Kee Club, Shanghai **www.keeclub.com**
Li Liang, Eastlink Gallery, 50 Moganshanlu, Shanghai
 www.eastlinkgallery.cn
Loft Restaurant, Beijing
Minneapolis Institute of Arts
Pearl Lam Galleries **www.contrastsgallery.com**
Pei Mansion Hotel, Shanghai
 www.peimansionhotel.com
Pier One Hotel, Shanghai
Red Capital Residence, Beijing
 www.redcapitalclub.com
Shikumen Wulixiang, Xintiandi, Shanghai
Suzhou Museum, Suzhou
The Fleming, Hong Kong **www.thefleming.com**
The V, Causeway Bay, Hong Kong **www.theV.hk**
Tiandijiya, Beijing

The Tuttle Story: "Books to Span the East and West"

Most people are very surprised to learn that the world's largest publisher of books on Asia had its beginnings in the tiny American state of Vermont. The company's founder, Charles E. Tuttle, belonged to a New England family steeped in publishing. And his first love was naturally books—especially old and rare editions.

Immediately after WW II, serving in Tokyo under General Douglas MacArthur, Tuttle was tasked with reviving the Japanese publishing industry, and founded the Charles E. Tuttle Publishing Company, which still thrives today as one of the world's leading independent publishers.

Though a westerner, Charles was hugely instrumental in bringing knowledge of Japan and Asia to a world hungry for information about the East. By the time of his death in 1993, Tuttle had published over 6,000 titles on Asian culture, history and art—a legacy honored by the Japanese emperor with the "Order of the Sacred Treasure," the highest tribute Japan can bestow upon a non-Japanese.

With a backlist of 1,500 books, Tuttle Publishing is as active today as at any time in its past—inspired by Charles' core mission to publish fine books to span the East and West and provide a greater understanding of each.

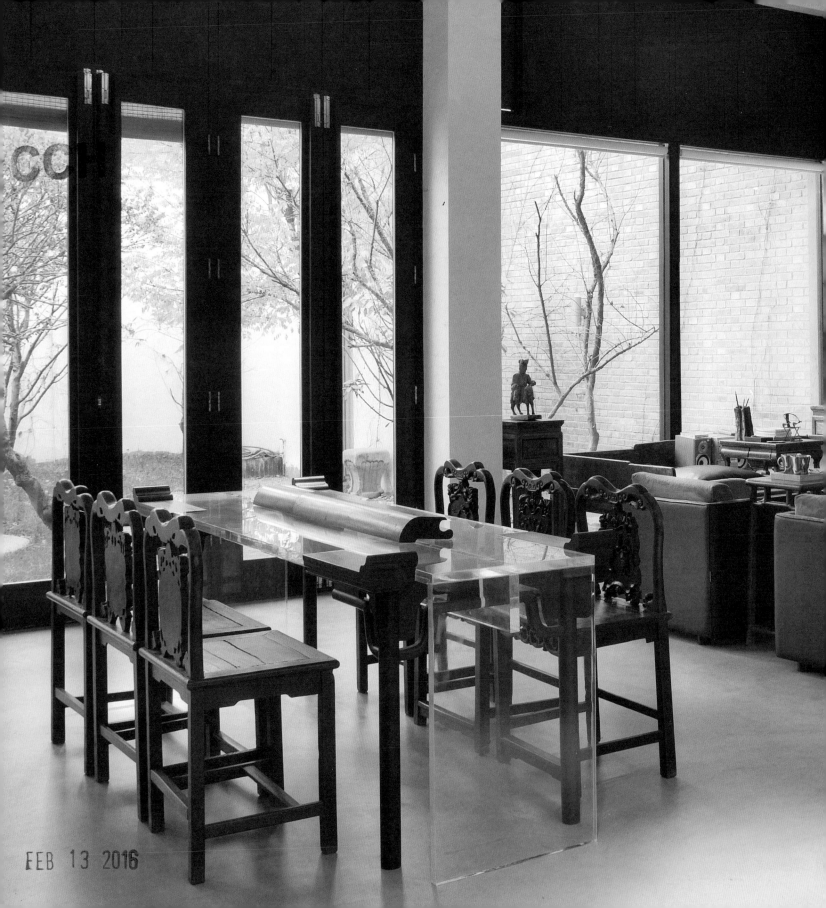